POSTCARD HISTORY SERIES

Narragansett

IN VINTAGE POSTCARDS

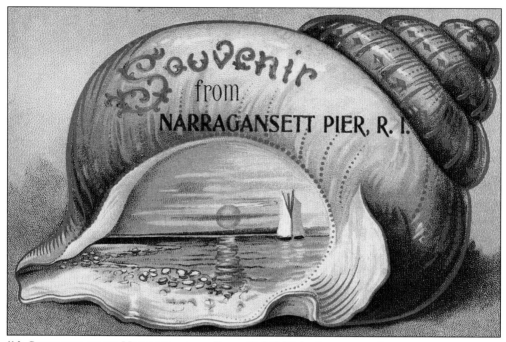

"A Souvenir from Narragansett Pier, R.I." [Pub. Anonymous.]

POSTCARD HISTORY SERIES

Narragansett

IN VINTAGE POSTCARDS

Sallie W. Latimer

ARCADIA

First published 1999
Reprinted 2004

Published by Arcadia Publishing,
an imprint of Tempus Publishing Inc.
Portsmouth NH, Charleston SC, Chicago,
San Francisco

Printed in Great Britain

Library of Congress Catalog Card Number: 99-62768

For all general information, contact Arcadia Publishing:
Telephone 843-853-2070
Fax 843-853-0044
E-mail sales@arcadiapublishing.com
For customer service and orders:
Toll-free 1-888-313-2665

Visit us on the Internet at www.arcadiapublishing.com

*This book is dedicated to Richard W. Latimer,
my helpmate and eternal companion.*

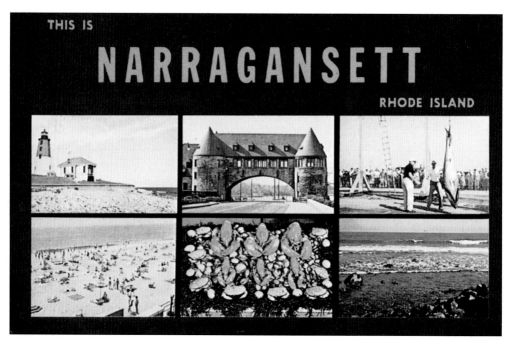

"THIS IS NARRAGANSETT, RHODE ISLAND." [Pub. © L.K. Color Productions, Providence, Rhode Island.]

CONTENTS

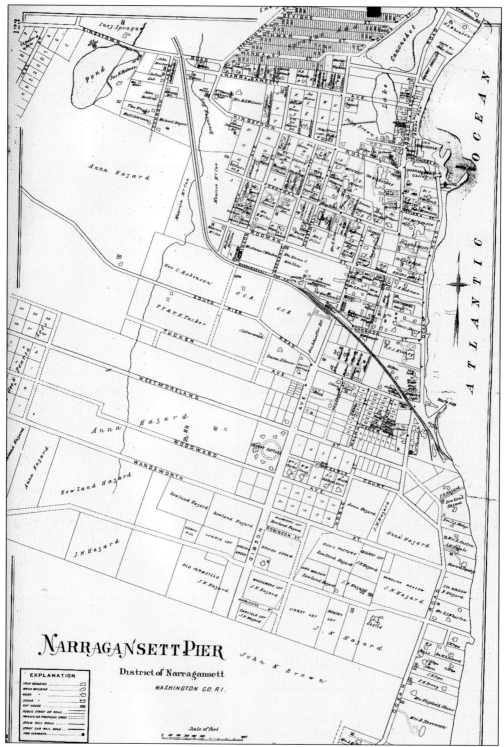

Narragansett Pier

District of Narragansett

WASHINGTON CO. R.I.

NARRAGANSETT PIER 1895 MAP FROM EVERT'S AND RICHARD'S *ATLAS OF SOUTHERN RHODE ISLAND.*

INTRODUCTION

Few events in history have been met with the same success and attention as the introduction of the postcard. Most postcard collectors consider the beautiful sets of cards printed for the 1892–93 Colombian Exposition in Chicago as the first U.S. picture postcards. Before the telephone, radio, and television, the postcard became a primary means of communication. It eliminated the time-consuming and cumbersome business of letter writing and furnished the ordinary person a glimpse of extraordinary places. Businesses also used the postcard as an inexpensive vehicle for advertising their goods and services.

What the early publishers and purchasers of postcards did not envision was the important role they would play in documenting local landmarks and history throughout the country. Postcards have always intrigued me. Little did I realize when I began collecting them as a 12-year-old girl that I would find such usefulness and meaning in understanding and interpreting the history of Narragansett, Rhode Island. Every postcard speaks volumes and it becomes an exciting and often intimate adventure to understand the language of that card. Narragansett has been particularly blessed because it attracted many fine photographers who have left us with a rich legacy of postcards from the late 19th century to the present. Photographer W.B. Davidson established his business in 1887. He was noted for traveling and giving "stereopticon and magical entertainment." Popular Charles Thurber, "Reckless Charlie," gained national prominence in 1892 for his photo of a beach scene. L.H. Clarke was well-established with a studio at the Pier, and J.H. Hollingsworth was known for his whimsical images.

While preparing this book, the most difficult decisions involved selecting cards to best illustrate Narragansett's fascinating history out of the many competing images. Of equal concern was the need to minimize redundancy with my first book, *Narragansett By-The-Sea*. This task was made a little easier since the first book used only images through 1900. In this volume, postcards are used to weave Narragansett's history into the 1970s. With

few exceptions, the images are different. Where the subject matter is the same (e.g. a Victorian hotel), a different image was selected.

The history of Narragansett is a history of transformations. The first significant transition began in the mid-19th century, when the rural farming community's seaside attractions began to draw tourists. Within 50 years, Narragansett became one of the best known and most fashionable summer resorts on the Atlantic coast. By the beginning of the 20th century, signs of change (the automobile) were evident. Once a resort where out-of-state residents came by train for extended vacations, it became largely a day-trip destination for Rhode Islanders. A transition in beach management also occurred from private to public ownership. By the 1920s, tastes had changed; more and more people had automobiles and could go where they pleased. There had been a world war and the society that developed the Pier as a seaside resort largely deserted it in favor of private clubs and exclusive destinations. The 1930s brought the Great Depression and the great hurricane, leaving the Pier a tarnished and decaying resort. Following World War II, an economic boom swept the country and Narragansett once again became a popular tourist destination. The surf still rolled in "with just sufficient force to increase the bathers exhilaration." However, by the 1970s, urban renewal had changed the physical character of the Pier, and in the age of the commuter the town grew rapidly as a residential community.

Postcards illuminate much about the transformations that have occurred during this century and the changing flavors and character of the Pier. I sincerely hope as you turn these pages, you will reflect on these images and absorb the ever so brief snippets of history presented. If so, you will not only be enlightened but will feel a deeper sense of the wonderful, unique history of Narragansett.

Author's Note: At the end of each caption, hard brackets [] enclose information identifying the postcard publisher. When that information was not available, the word "anonymous" will appear. Many captions include quoted information. The source reference will follow the quote and be enclosed by parenthesis ().

One
NARRAGANSETT PIER

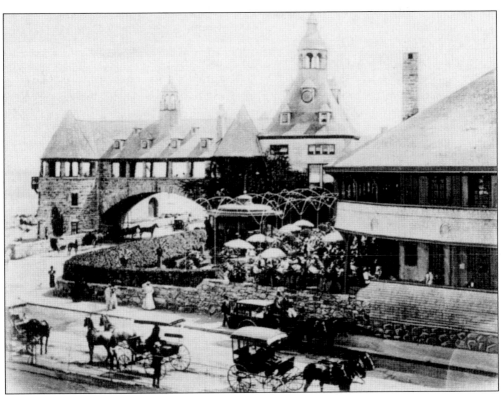

TOWERS AND THE CASINO, C. 1897. "To many the abiding attraction of Narragansett is not the gift of nature but the work of man. They insist that the real reason for its persistent popularity is to be found not in the place so much as in the people who have made it what it is and who have shaped its social character" (Brander Matthews, *Harper's Weekly*, 1906). The Narragansett Casino was a favorite among attractions at the Pier and served as the center of social life for the summer colony. This image by W.B. Davidson is a highly prized postcard. [Pub. Rhode Island News Co., Providence, Rhode Island.]

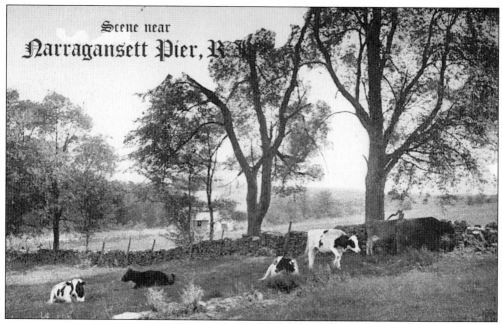

Scene near **Narragansett Pier,** **R. I.**

SCENE NEAR NARRAGANSETT PIER, C. 1910. For much of the first half of the 19th century, Narragansett remained a sparsely populated rural community. Dairy farms were common, and families like Robinsons, Hazards, Watsons, Mumfords, and Knowles were prominent in producing and exporting dairy products. Today the farms have given way to subdivisions, roads, and business development. [Pub. M.L. Metrochrome.]

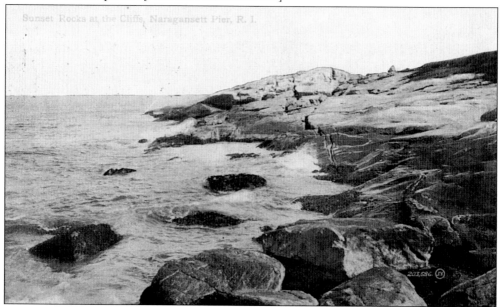

SUNSET ROCKS AT THE CLIFFS, C. 1910. Several miles of rugged pink granite outcropping makes up the shoreline of Narragansett. The cliffs provided a scenic getaway for the hardy and a challenge for fisherman casting for bass and blue fish. They also provided a spectacular location for the large summer cottages of the rich and famous. Today, it is a popular vista for filming, fishing, and special occasions. [Pub. Valentines and Sons, New York.]

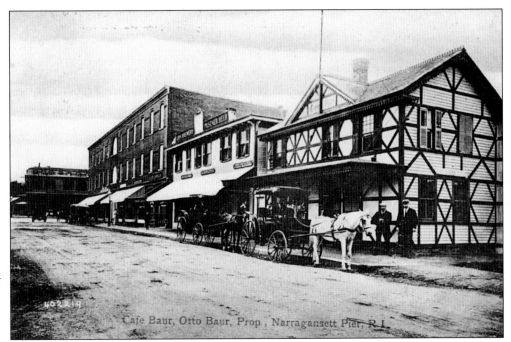

BEACH STREET LOOKING SOUTH, C. 1907. Baur Cafe (at the right of picture) was built *c.* 1894. Otto Baur, posing in front of the cafe, was a well-known immigrant engaged in a number of Pier enterprises. He died in 1918, but the cafe endured until 1961, when it was razed to make room for a new cafe and lounge. [Pub. Valentine and Sons, Ltd., New York.]

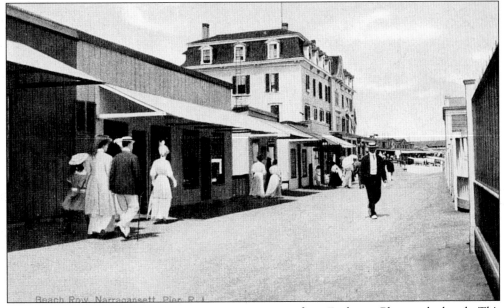

BEACH ROW, C. 1905. Beach Row was a narrow access from Exchange Place to the beach. This unusual scene captures a sense of the business activity at the head of the beach. Following the fire of 1900, which destroyed the Hazard Block, a group of small shops on the left sprang up in temporary quarters. The large four-story structure is the Burnside Hotel, which was moved to the beach in 1902. [Pub. Metropolitan News Co., Boston, Massachusetts.]

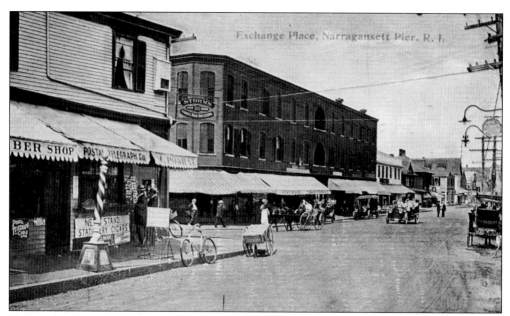

EXCHANGE PLACE, C. 1910. The intersection of Kingstown Road, Beach Street, Mathewson Street, and Exchange Place was generally considered the center of town. It was certainly a natural hub of business activity. This view, looking north down Beach Street, highlights the Caswell Block on the left, with Clarkes dominating the center of the scene. [Pub. Charles H. Seddon, Providence, Rhode Island.]

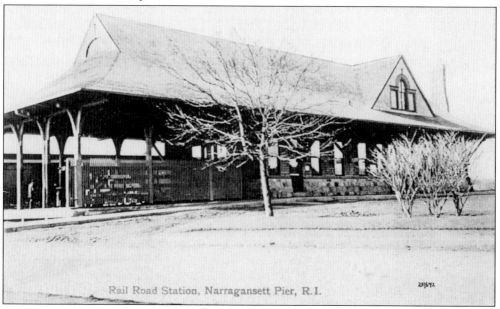

Rail Road Station, Narragansett Pier, R.I.

RAIL ROAD STATION, C. 1898. The Narragansett Pier Railroad was built in 1876 connecting the Stonington Railroad in West Kingston to the Pier. "Fueling an ever increasing commerce in business and people, a new passenger station was constructed on Boon Street in 1896" (*A Short Haul to the Bay—A History of the Narragansett Pier Railroad*, 1969). It served the railroad until 1953, when service was terminated to Narragansett. Today, an apartment and business occupy the former station. [Pub. Valentine & Son's Co., Ltd., New York.]

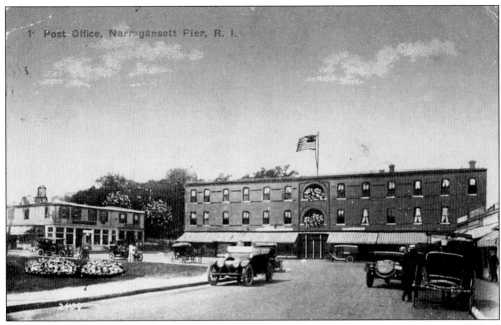

POST OFFICE, *C.* **1912.** Looking west along Exchange Place, the dominant structure is Clarkes, which housed the post office until the new office building was constructed. The old Narragansett Casino grounds on the left have been cleaned, leveled, and planted to create a park-like environment. [Pub. Danziger & Berman, New Haven, Connecticut.]

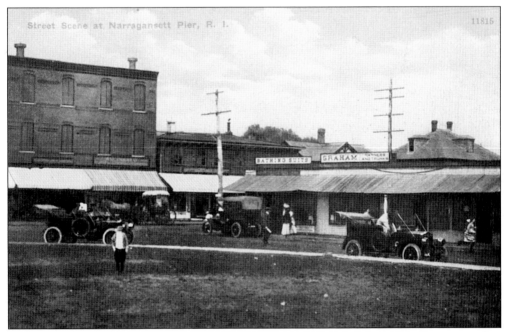

STREET SCENE, *C.* **1910.** This scene is similar to the one at the top of the page but was taken from the old Narragansett Casino grounds looking northwest. The small shops in the right foreground sprang up after the Hazard Block burned in 1900. They would soon be replaced by the new post office building. [Pub. A.C. Bosselmen & Co., New York.]

13

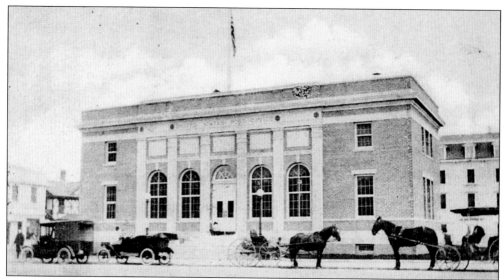

U.S. POST OFFICE, C. 1915. The post office was completed in 1915 and provided a new anchor for a growing center of town. The first post office at the Pier was established by William C. Caswell in 1865 at his place of business. For most of the next 40 years, a Caswell was the postmaster. The new brick building, 69-by-62 feet with classical detailing, remains in full operation. [Pub. Rhode Island News Co., Providence, Rhode Island.]

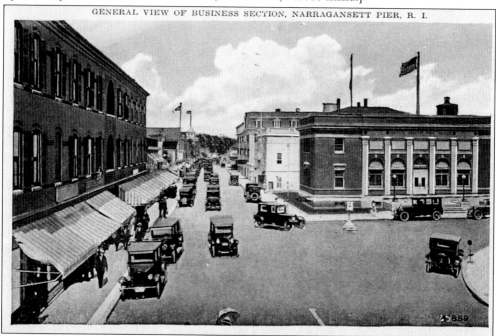

EXCHANGE PLACE, C. 1920s. The center of the Pier appears busy. Directly behind the post office is a new building, the Casino Theatre. Constructed in 1916 for John Hanan, it extended 100 feet from Beach Street to Beach Row. Seating capacity was over 800, including the balcony. The modern facility provided motion picture entertainment for over 50 years. John W. Miller purchased it in 1922. It was torn down in 1974 to make way for urban renewal. [Pub. Berger Brothers, Providence, Rhode Island.]

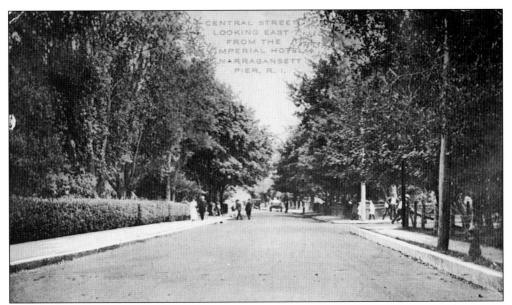

CENTRAL STREET LOOKING EAST, C. 1912. Central Street was platted in 1867 but remained largely undeveloped until the 1880s and 1890s. In this view, Boon Street can be seen intersecting at right with the Imperial Hotel hiding among the trees on the left. Central Street did not connect to Ocean Road until 1919. [Pub. Rhode Island News Co., Providence, Rhode Island.]

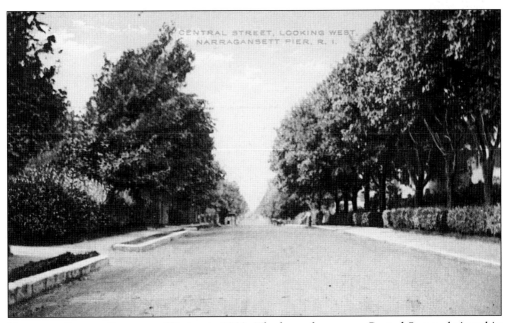

CENTRAL STREET LOOKING WEST, C. 1912. The larger homes on Central Street, designed in the Colonial, Queen Anne, and Shingle styles, were set back from the street on large landscaped lots. The white structure just visible through the trees is Homeleigh. Of interest are the well-maintained street, sidewalks, and curbing. [Pub. Rhode Island News Co., Providence, Rhode Island.]

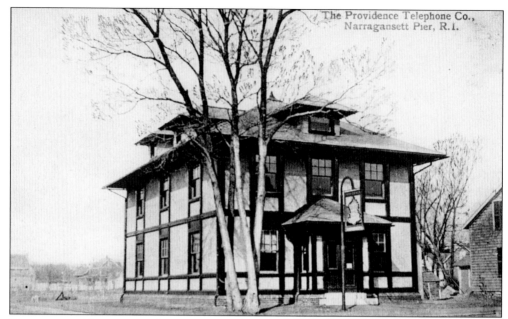

The Providence Telephone Co.,
Narragansett Pier, R.I.

PROVIDENCE TELEPHONE CO., C. 1908. The telephone system came to the Pier in 1879. In 1905, the Providence Telephone Co. constructed a 30-by-40-foot, two-story building on the corner of Boon and Rodman Streets. Equipment and linesmen's rooms were on the first floor. Offices and telephone operators occupied the second floor. The telephone company moved to Wakefield in 1952 when the dial system began. Today, the sturdy structure on Boon Street is maintained as a private residence. [Pub. Valentine and Sons Co., Ltd., New York.]

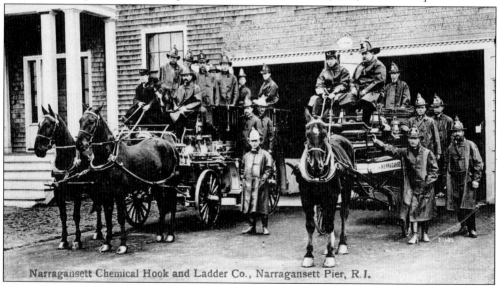

Narragansett Chemical Hook and Ladder Co., Narragansett Pier, R.I.

CHEMICAL HOOK AND LADDER CO., C. 1908. The Narragansett Pier Volunteer Fire Department was organized in 1889. In 1908, the fire department purchased a two-horse combination hose and chemical wagon capable of carrying 12 men. Here men, horses, and equipment pose in front of the station at the old town hall at 69 Rodman Street. The department moved to its present location on Caswell Street in 1979. [Pub. Valentine and Sons Co., Ltd., New York.]

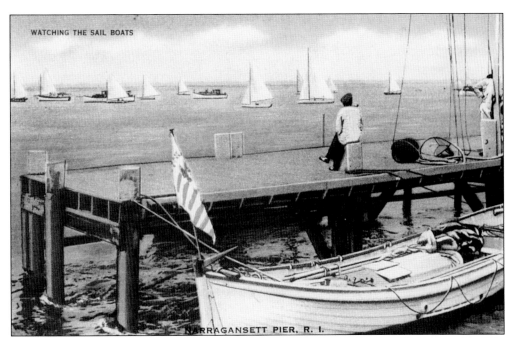

WATCHING THE SAIL BOATS, C. 1906. The North Pier was rebuilt in 1905 to accommodate yacht landings at the new casino. It also served the U.S. Life Saving Service crews at their new station next to the Towers. A rough stone breakwater helped protect the pier from ocean waves rolling in from the stormy Atlantic. [Pub. Colour Picture Cambridge, Massachusetts.]

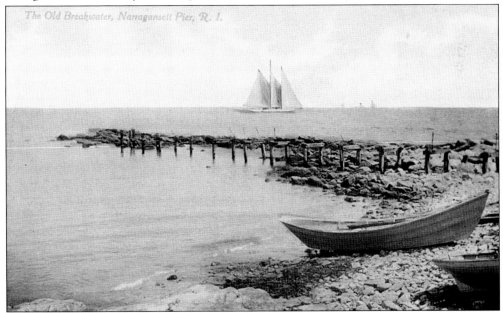

THE OLD BREAKWATER (NARRAGANSETT NORTH PIER), C. 1925. Time and winter storms reduced the breakwater to rubble and the pier to ragged piling. With the advent of the automobile age, it was no longer fashionable to "yacht to the Pier," thus relieving the need to maintain a structure that was so vulnerable to the elements. [Pub. H.A. Dickerman & Son, Taunton, Massachusetts.]

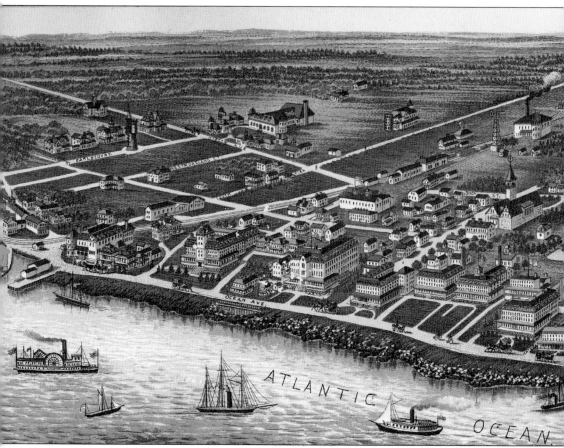

NARRAGANSETT PIER, C. 1890. A graphic artist's rendering of the Pier area shows a dramatic transformation during the previous 25 years from an obscure agricultural village to a stunning summer, seaside resort second to none. "One may search the coast from Maine to Florida in vain to find a more charming resort. Its climate, its scenery, all combine to give Narragansett Pier unequaled advantages" (*Souvenir Book*, Narragansett Pier, RI: Hotel Men's Association, 1891). Fifteen large hotels plus a number of smaller "inns" populated the Pier area. The old casino, with

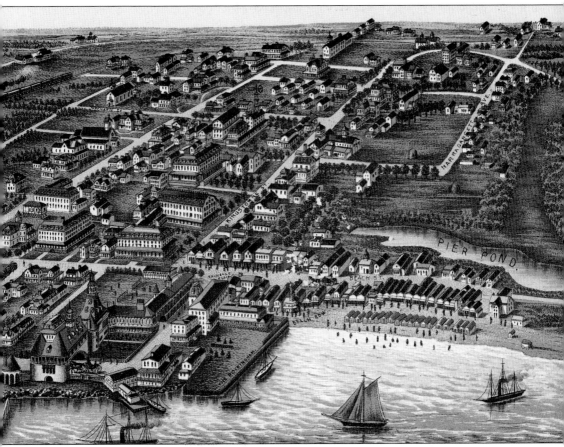

its imposing stone towers, is situated adjacent to the bay and near the entrance to the beach. Four major churches had been erected to serve both the summer and permanent residents. Numerous small businesses thrived with the growing population. Some 25 imposing cottages occupied the rugged shoreline south of the hotels; an equal number of smaller homes filled in the center of town.

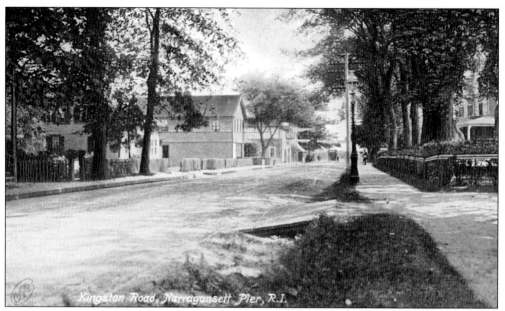

KINGSTON ROAD, C. 1908. Looking east toward the bay, this quiet scene could represent the spring season. Peeking from behind the large trees on the right is the Gladstone Hotel. The Sea View Hotel (left) is nearly covered by the trees. Other small businesses can be seen just beyond. Kingstown Road (19th-century maps spell it Kingstowne) was the main artery west from town connecting Wakefield and Post Road. [Pub. Robbins Bros. Co., Boston, Massachusetts.]

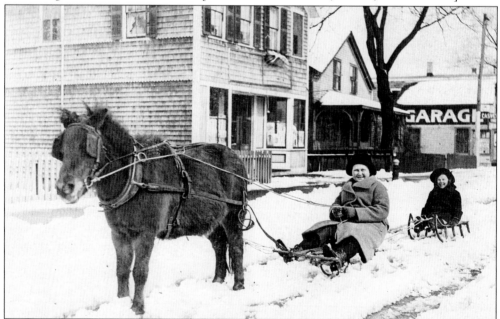

A RIDE IN THE SNOW, C. 1917. Snow was not much of an inconvenience in winter. The summer residents have departed and Narragansett has reverted back to a quiet rural community. In this scene, the children have taken advantage of the snow and enlisted Jumbo, the favorite pony of the Peleg Brown family, for a sleigh ride down Kingstown Road. [Pub. Anonymous Photoprint.]

20

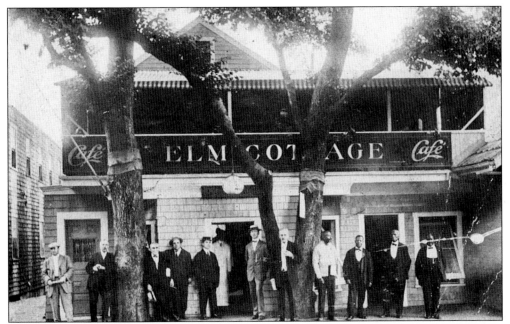

ELM COTTAGE, C. 1907. Posed in front are proprietor M.A. Webster, the staff, and guests of the well-known establishment on Kingstown Road. Mervin Almon Webster came to Narragansett in 1888 and opened a livery stable. In 1893, he built Elm Cottage adjacent to his stable on Kingstown Road and managed the popular establishment until his death in 1908. [Pub. Anonymous.]

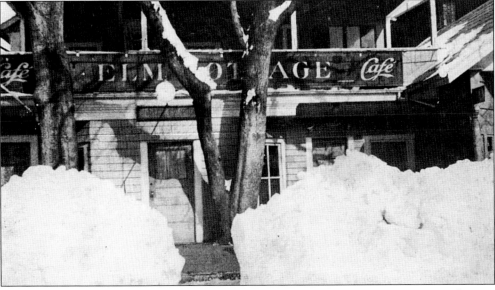

COOLEST PLACE AT THE PIER, C. 1904. Elm Cottage, like many establishments, was only open during the summer season. "Knee deep snow, all past records of cold weather have been broken this week" (*Narragansett Times*, January 8, 1904). Elm Cottage was home to the Roof Club, one of several exclusive establishments catering to the faster crowd who enjoyed gambling. The building became part of the Ocean View Hotel and was torn down in the 1960s. [Pub. Anonymous.]

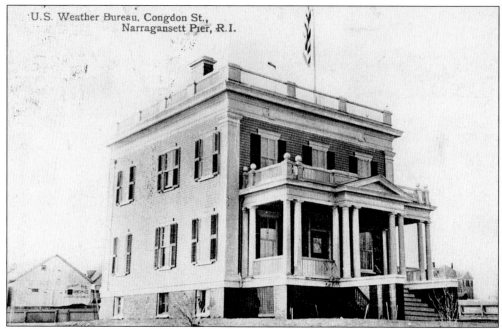

U.S. WEATHER BUREAU, C. 1905. In 1870, Congress set up a national weather service as part of the Army Signal Corps. It became the Weather Bureau in 1890. A "signal station" was established in 1881 and manned by Sgt. John O. Conway. In 1903, this structure was built on Congdon Street and occupied by Mrs. Margaret Conway, who succeeded her deceased husband in the bureau. There were five rooms on the first floor, including two offices, and four sleeping rooms on the second floor. When the bureau vacated the building in 1938, it became a private residence, and though significantly modified, it remains at its original location. [Pub. Valentine & Sons Co. LTD, New York.]

MATHEWSON STREET, C. 1912. The short street between Kingstown Road and Central Street connected the Mathewson and Massosoit Hotels and adjacent cottages to the Narragansett Casino grounds and the center of the Pier. The finished sidewalks and curbing made a stroll during the day an enjoyable experience. [Pub. Rhode Island News Co., Providence, Rhode Island.]

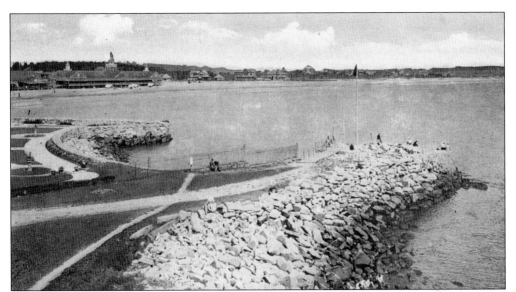

OLD STONE PIER, C. 1908. This was the site of a late-18th-century pier built by John Robinson. It remained prominent for the next 100 years as a number of owners built and rebuilt structures to facilitate commerce at what became known as Narragansett Pier. In the early 20th century, the "yacht landing" provided docking facilities and a sheltered cove for small water craft. [Pub. Louis Couchon, Narragansett, Rhode Island.]

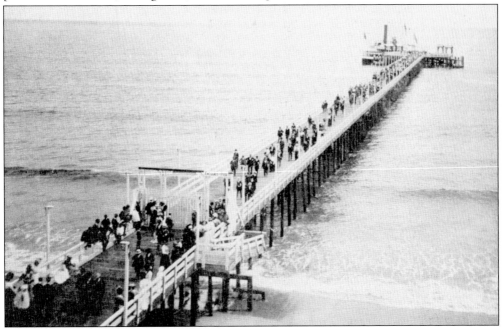

STEAMBOAT LANDING, C. 1900. This landing was constructed in 1897 by the Providence, Fall River, and Newport Steamboat Company to capitalize on the demand for transportation to the Pier. "The steamer Mt. Hope made a run from Providence to Block Island, via Newport and the Pier in three and three quarters hours" (*Narragansett Times*, July 10, 1903). The landing and steamboats became casualties of changing times and the automobile, and by 1908 it was dismantled. [Pub. Anonymous.]

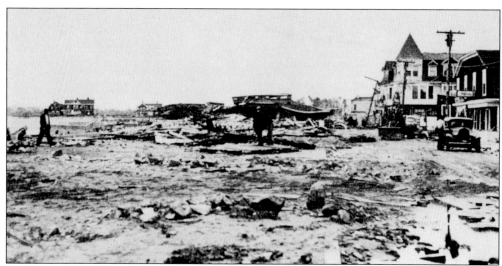

Beach Street, c. 1938. Many photographs were taken during and after the devastating hurricane of September 21, 1938. This is one of the few pictures that was published as a postcard. Beach Street and virtually all of the structures on the beach were destroyed. Thirteen remaining buildings on Beach Street were condemned. "Thirteen cars and a school bus have been pulled out of the Pier Pond and there are at least two more automobiles resting there on the bottom" (*Narragansett Times*, September 10, 1938). [Pub. Tichnor Bros. Inc., Boston, Massachusetts.]

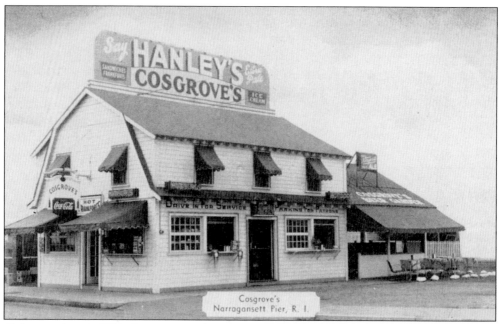

Cosgrove's, c. 1940. Businesses such as Cosgrove's sprang up on Beach Street in the 1930s catering to the "day-trippers." The postcard back reads: "Your first stop at Narragansett Pier for famous hot dogs and dee-licious hamburgers." Before Cosgrove's, locals remember it as "Edwin's Tap," which was operated by Dr. Edwin Roche. In the *Souvenir Guidebook*, published on July 8, 1955, it is listed as Walsh's and was mentioned as being "air conditioned for your comfort," featuring "sea food at its best." [Pub. Vincent Payne, Photographer, Providence, Rhode Island.]

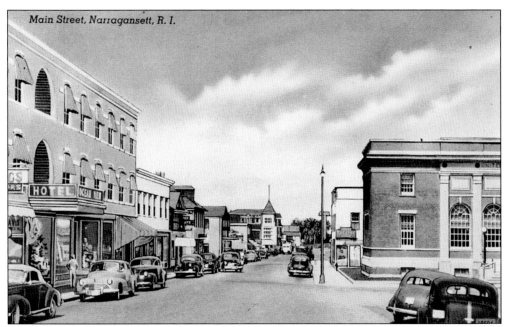

MAIN STREET LOOKING NORTH, C. 1946. The business district at the Pier took on a "newer" look from the significant rebuilding after the 1938 hurricane and World War II. However, sturdy old structures such as the post office, the Ocean View Hotel, the Surf Hotel (the steepled building in center), and the Casino Theater (behind the post office on the right) are visible. [Pub. Narragansett Gift Centre, Narragansett, Rhode Island.]

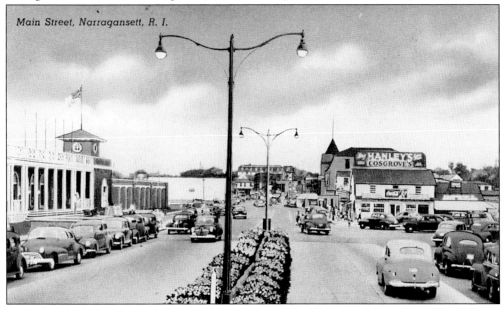

MAIN STREET LOOKING SOUTH, C. 1946. Known as Beach Street, this section of the highway received major reconstruction after the 1938 hurricane. The new bathing pavilion is on the left while Cosgrove's, which survived the hurricane, can be seen at right. The four-lane divided highway with ample parking is an acknowledgment of the automobiles' persuasive influence. [Pub. Narragansett Gift Centre, Narragansett, Rhode Island.]

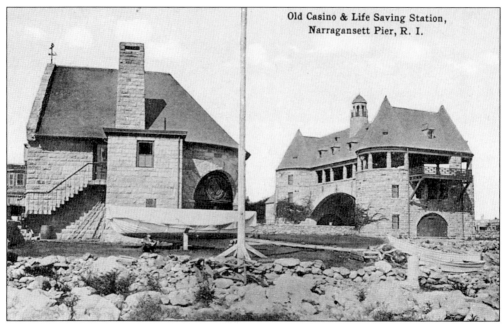

Old Casino & Life Saving Station,
Narragansett Pier, R. I.

OLD CASINO AND LIFE SAVING STATION, C. 1912. This view is looking west from the breakwater and shows the Towers with its roof and cupola restored. Also, the wooden balcony extending from the east tower has been replaced. Residents and visitors alike were delighted to see the symbol of old Narragansett once again in proud array. The Towers would remain vacant, however, with only occasional use until 1924. [Pub. Pier News Co., Narragansett, Rhode Island.]

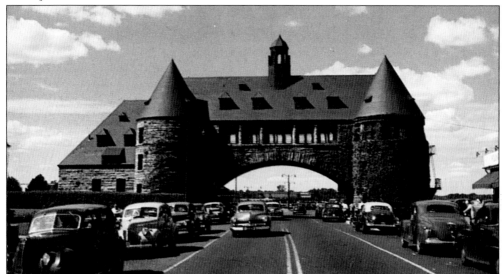

HISTORIC ARCH, C. 1950. "To modern eyes the Towers at Narragansett is a striking if bizarre monument, forlorn in its isolation like the gateway to some abandoned medieval town or a bridge between one vanished place and another. 'The stone skeleton of its springing archway, (wrote novelist Brander Matthews early in the century) is majestic even in its empty uselessness' " (Maury Klein, *Nineteenth Century*, Spring 1984). [Pub. Alman's Photo Supply Wakefield, Rhode Island.]

Two
WASHED BY SUN AND SEA

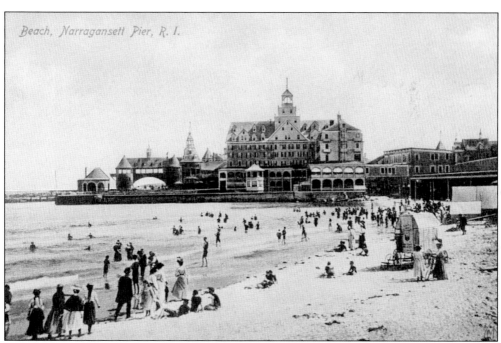

Beach, Narragansett Pier, R. I.

THE BEACH LOOKING SOUTH, c. 1900. The beach provided a spectacular vantage-point to view the Pier area. Both the Narragansett Casino and majestic Rockingham Hotel are seen prior to the disastrous fire of 1900. "The beach is so level and the water in fine weather so quiet it needs little courage to walk out to one's armpits. At this depth we shall find a fringe of lively people in the very hey day of robust enjoyment" (*Harper's Weekly*, 1879). [Pub. Anonymous, printed in Belgium.]

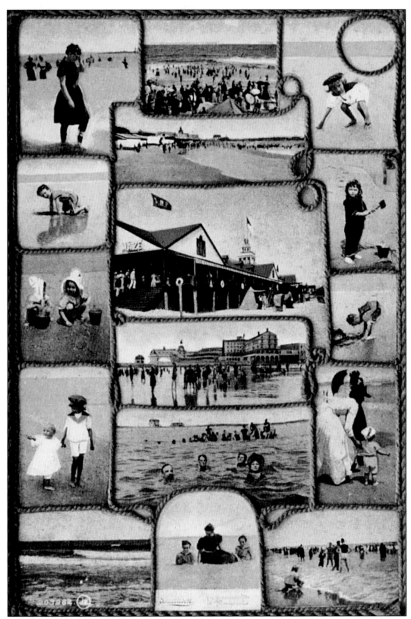

SCENES ON THE BEACH, C. 1900. Multi-view postcards were popular at the turn of the century. Each image displayed a spirited message of fun and an enticing "wish you were here." "The beach at Narragansett Pier is a veritable children's paradise. The blue ocean and the colorful shelter tents erected on the beach in front of the bathing houses presented a kaleidoscope of color. The gaiety of this scene was complete with an Italian Band and jubilee singers who made plenty of music about the streets and beach" (*Narragansett Times*, 1898). "It is the beach which is the center of life at Narragansett . . . It is on the beach at the bathing hour that the transient guests of the hotels have their chance to mingle with the cottagers who have been coming summer after summer, unable to keep away and who are swift to insist that there is nowhere else a seaside village worth of comparison with Narragansett" (Brander Mathews, *Harper's Weekly*, 1906). [Pub. Valentine & Sons Pub. Co. Ltd., New York.]

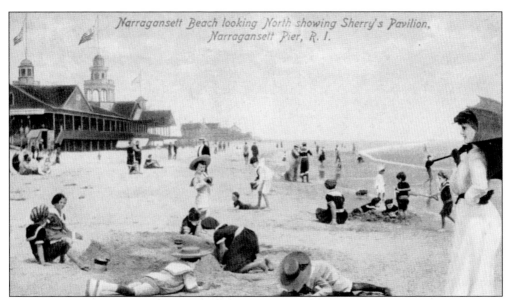

NARRAGANSETT BEACH LOOKING NORTH, c. 1898. "Nothing could be prettier than dainty summer hats, shifting and changing like a kaleidoscope and enlivened by a cheerful chatter of feminine tongues. The same scene is repeated all down the beach, where the permanent bathing houses on the sandy ridge, with their sheltered gable ends and benches looking seaward" (*Harper's Weekly*, 1879). [Pub. The Metropolitan News Co., Boston, Massachusetts.]

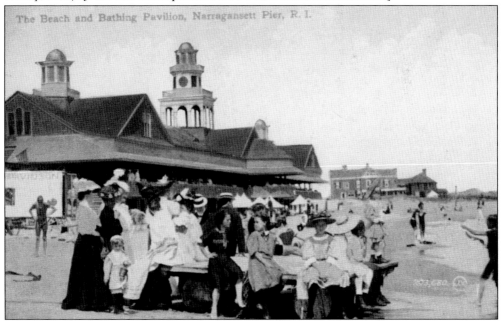

BEACH AND BATHING PAVILION, c. 1896. "This is the morning attraction where everybody goes to see and be seen. Thousands go to take a dip in the briny deep, the surf of which is all the bather can desire. The breakers come rolling in in rapid succession, with sufficient force for exhilaration to the bather. So safe is the beach that neither life boat or lines are required" (*Souvenir Book*, Narragensett Pier, RI: Hotel Men's Association, 1891). [Pub. Valentine & Sons Publishing Co., Ltd., New York and Boston.]

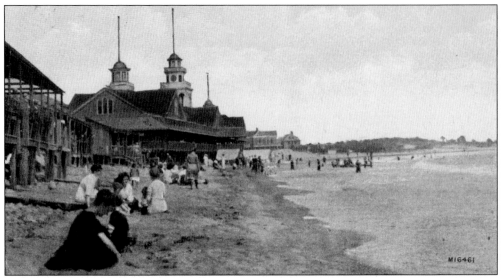

THE BEACH, C. 1905. Narragansett Beach was always alive with activities. Sherry's Pavilion provided music, roller skating, and a bicycle rink. "Charles I.D. Looff (famous carousel designer and builder) dismantled one of his carousels, and floated it to Narragansett Pier. A domed building was constructed at the beach to house the merry-go-round" (Winnie Kissouth, *Personal Notes*, 1978). [Pub. Anonymous.]

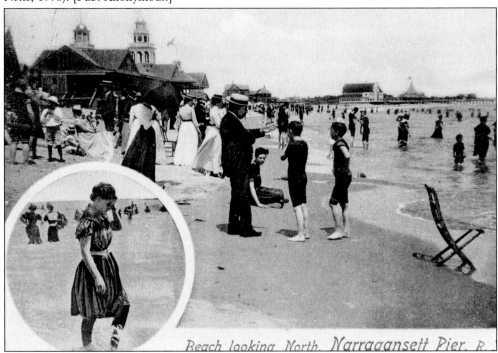

BEACH LOOKING NORTH, C. 1900. Narragansetts' famous beach attracted creative entrepreneurs like John Davis who "secured the agency for the Neptune life-saving bathing suit, which by inflation secures a chamber around the upper portion of the body, and makes it impossible for its wearer to even sink, and it is so arranged that it cannot be detected" (*Narragansett Times*, August 28, 1891). [Pub. National Art Views Co., New York.]

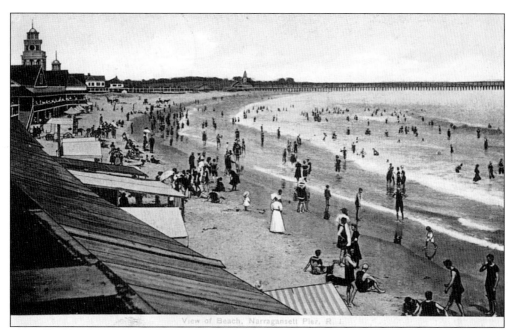

A View of the Beach, c. 1900. South of Sherry's Pavilion, numerous bathhouses (many supplied hot sea-water showers) sprang up like mushrooms. "Striped tents and colorful umbrellas presented a cheerful picture. The beach probably is entitled to rank first in attraction. Imagine a beautiful crescent-shaped beach, stretching for more than a mile, with its silvery sands glistening in the summer sun, descending gradually to the waters edge" (*Souvenir Book*, Narragensett Pier, RI: Hotel Men's Association, 1891). [Pub. Valentine & Sons Pub. Co., Ltd., New York.]

Studio Photograph, *c.* **1906.** Photographers began producing postcards from studio photographs at the turn of the century. Early cards left a space on the front for correspondence. The back was used exclusively for the address. The U.S. Government permitted use of the divided back in 1907. Note the old Narragansett Casino in the background. [Pub. Anonymous.]

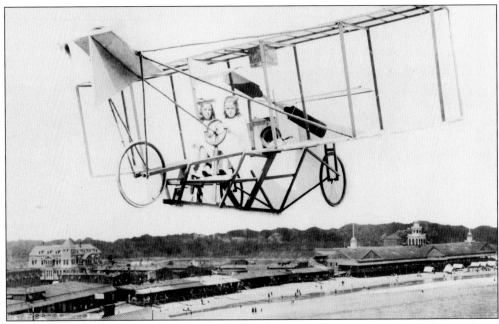

FLYING HIGH OVER THE BEACH, C. 1907. This fascinating illusion was created using a painted studio backdrop of the airplane with the children perched aboard, superimposed over an image of Sherry's Pavilion and the beach. Technology was rapidly advancing and photographers were quick to embrace it. [Pub. J.A. Hollingsworth, Beach Front, Narragansett Pier, Rhode Island.]

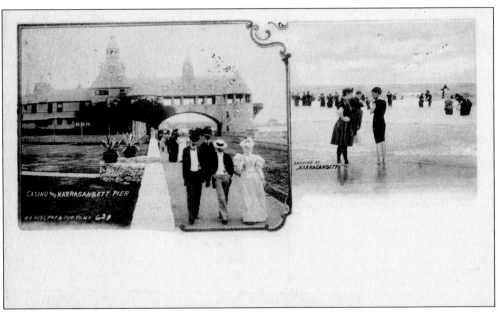

FAVORITE PASTIMES, C. 1898. This early postcard combined two images with room on the card front for a short message. Private mailing cards were authorized by Congress in 1898. Two favorite pastimes were bathing at the beach and strolling. Bathing hours were from 11:00 a.m. to 1:00 p.m., which left afternoons free for strolling about, showing off the latest fashions, and enjoying a walk along the sea wall. [Pub. Postal Card–Carte Postale.]

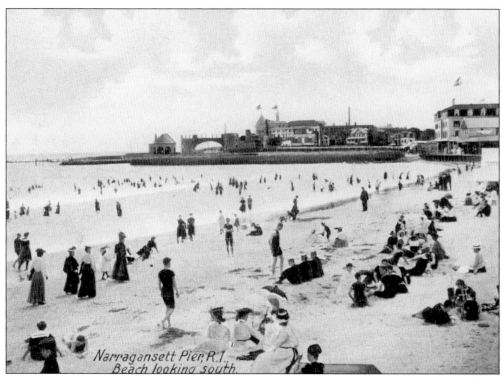

Narragansett Pier, R.I.
Beach looking south.

**BEACH LOOKING SOUTH,
C. 1903.** The Pier has taken on a very different appearance following the 1900 fire. Gone are the Rockingham Hotel and the Narragansett Casino. Only the Towers, shorn of its wooden roof structure, remains. A new addition to the beachfront is the Burnside Hotel (at the right of picture), which was moved from Ocean Road. [Pub. H.C. Leighton Co., Portland, Maine.]

OFF ON A LARK, C. 1905. Georgia and Daisy were probably captured on film at Clarke's Studio. The short message "off on a lark," handwritten on the card, was dated August 9, 1905. Georgia was the daughter of L.H. Clarke, the well-known photographer. [Pub. Anonymous.]

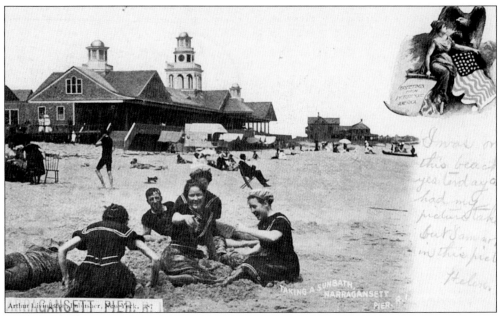

TAKING A SUNBATH, C. 1902. Sherry's Pavilion was the most prominent and popular place on the beach. Bathing suit fashions were as important then as now. "The Narragansett bathing costume is artistically at least an improvement on the conventional pattern. New arrivals pick out bathing dresses at the country store, deep in the choice of blue flannel, waist belts, and fancy stockings" (*Harper's Weekly*, 1879). [Pub. Arthur Livingstone, New York.]

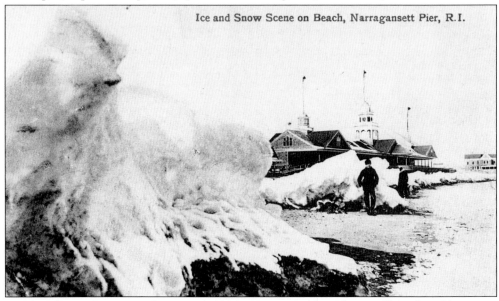

Ice and Snow Scene on Beach, Narragansett Pier, R.I.

ICE AND SNOW SCENE ON BEACH, C. 1904. Winters past have been sufficiently cold to cause portions of Narragansett Bay to be covered with thick ice. "An unusual sight in front of the bathing houses on the beach, the past few days, has seen an immense quantity of ice and snow piled up to the height of seven and eight feet. At low tide one could walk between the ice and water and not be seen from the bathing house veranadas" (*Narragansett Times*, February 19, 1904). [Pub. Valentine & Sons Pub. Co. Ltd., New York.]

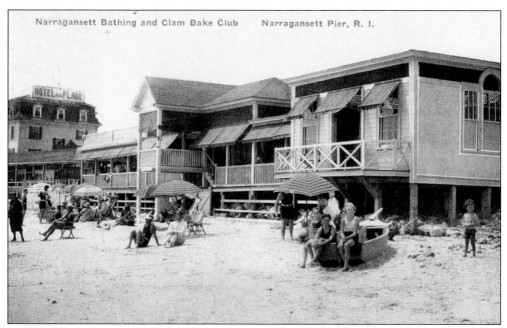

NARRAGANSETT BATHING AND CLAM BAKE CLUB, C. 1925. By the early 1920s, Narragansett's social elite tried various ways to separate themselves from the transients and town natives. They formed the Narragansett Improvement Association, which acquired the Burnside Hotel and several stores and bathhouses adjoining the hotel property. The hotel was renamed the De La Plage and the Bathing and Clam Bake Club was constructed. [Pub. Greens Art Store, Narragansett, Rhode Island.]

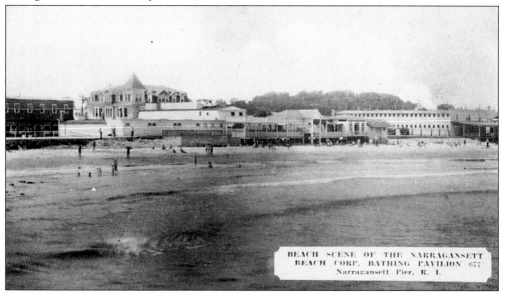

NARRAGANSETT BEACH CORP. BATHING PAVILION, C. 1932. The early 1930s brought further change to the beach due to changing social and economic conditions. The De La Plage was acquired by the Town and torn down; a public park was created on the site. The Clam Bake Club remained, however, and a new bathing pavilion (Palmers) was constructed adjacent to it. [Pub. Dexter Press, Pearl River, New York.]

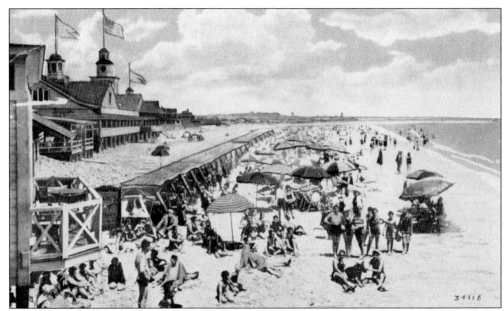

BATHING BEACH, C. 1931. This view looking north from the Clam Bake Club shows a straight line of portable beach cabanas separating the permanent structures from the water front. Abbreviated bathing suits showing bare arms and legs have made their appearance. An influx of spend-the-day visitors caused the town council to ask for federal aid to construct bathhouses that would accommodate 2,000 persons. [Pub. Berger Bros, Providence, Rhode Island.]

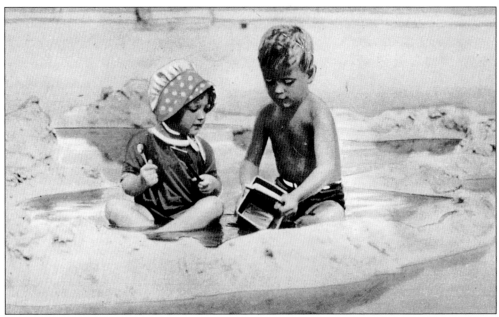

PLAYTIME ON THE BEACH, C. 1930S. The magic of the beach has always attracted children. Sand castles and moats and things that wiggle or float can keep little ones occupied for hours. Narragansett's beach was always a special place for playful children. [Pub. Colourpicture Publication, Boston, Massachusetts.]

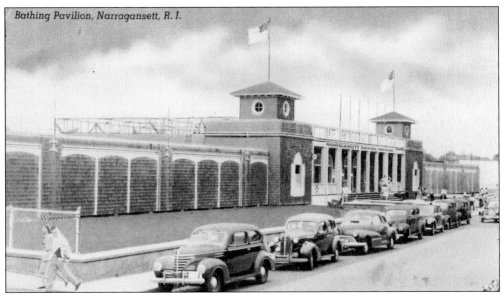

Bathing Pavilion, Narragansett, R. I.

BATHING PAVILION, C. 1940S. Following the 1938 hurricane, the town of Narragansett moved to acquire much of the old beach property that was in private ownership. A new bathing pavilion was erected near the site of Sherry's old pavilion. A beach commission was organized to manage the acquisition of property and administer the new beach operations. However, beach facilities would suffer another crippling blow by the 1954 hurricane. [Pub. Narragansett Gift Centre, Narragansett, Rhode Island.]

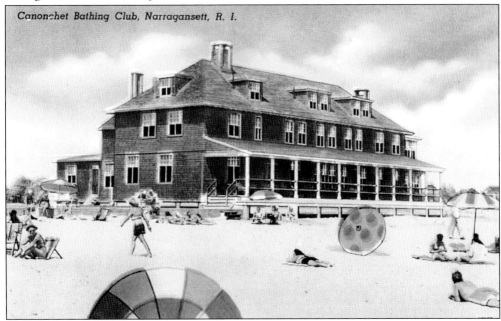

Canonchet Bathing Club, Narragansett, R. I.

CANONCHET BATHING CLUB, C. 1940S. This handsome structure was constructed by the Town after the 1938 hurricane had damaged two private homes on the site. Canonchet provided resident and nonresident subscribers with overnight accommodations and entertainment facilities. It suffered fatal damage in the 1954 hurricane and had to be rebuilt. [Pub. Narragansett Gift Centre, Narragansett, Rhode Island.]

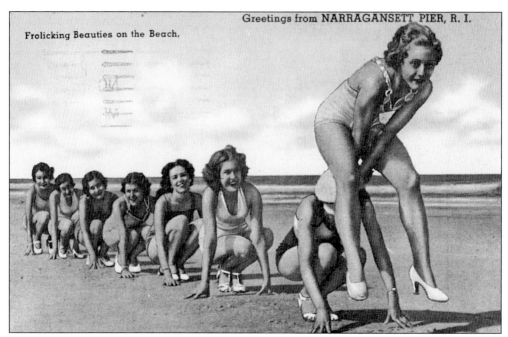

FROLICKING BEAUTIES ON THE BEACH, C. 1941. The message on the back of the card reads: "Nancy dear, spent the day on the beach with grandma and Robinson. The water was wonderful. We will go to the Pier when you get home. Love, Mother, Dad, Sue." [Pub. Anonymous.]

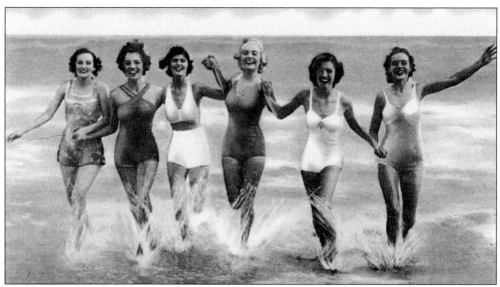

BATHING BEAUTIES ON THE BEACH, C. 1950. Good times returned to Narragansett Pier after World War II. The beach once again became a popular playground. One- and two-piece bathing suits for women were both flattering and functional. "There's fun here for guests of all ages, whether you like to swim, sail, fish or just loaf in the sun. The wide sandy beach slopes gently down to the blue Atlantic—warmed by the Gulf Stream for pleasant swimming" (Narragansett Chamber of Commerce, 1950). [Pub. Colourpicture Publication, Boston, Massachusetts.]

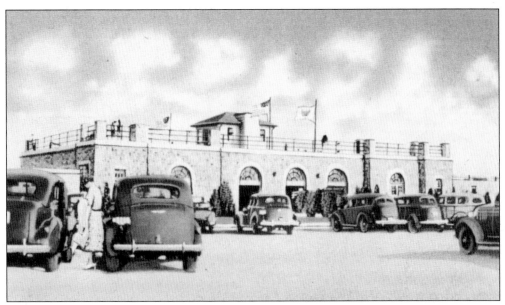

SCARBOROUGH STATE BEACH, C. 1938. Just after World War I, Narragansett's summer residences forsook the Pier beach, which had seen a large influx of transients. The Scarborough Beach Club was organized and a large bathing pavilion constructed. They got their privacy, but it was too isolated and they decided to reclaim a portion of the beach near Sherry's Pavilion. Scarborough became a public beach, but the pavilion was destroyed by fire in 1934. The State then constructed the stone structure, shown above, in 1938. [Pub. Berger Bros., Providence, Rhode Island.]

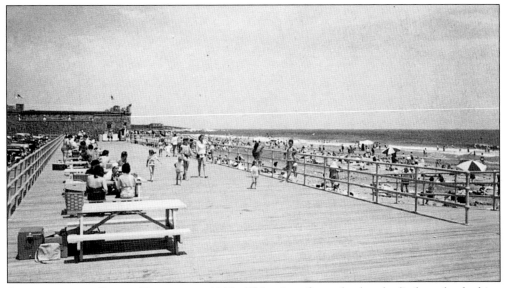

SCARBOROUGH STATE BEACH, C. 1940. This view from the beach displays the bathing pavilion's handsome stone architecture. Scarborough has always been a popular beach and its pavilion survived the 1938 hurricane. The structures we see today are the result of a refurbishing and expansion program in 1988. Scarborough and Scarborough South are operated and maintained by the State of Rhode Island. [Pub. Berger Bros., Providence, Rhode Island.]

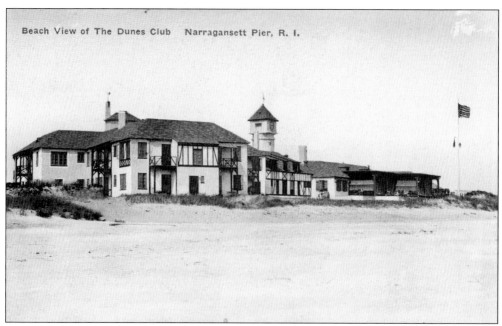

Beach View of The Dunes Club Narragansett Pier, R. I.

THE DUNES CLUB, C. 1930. In 1928, the Dunes Club was organized by the socially prominent in a continued search for beachfront exclusivity. New York architect Kenneth M. Murchison designed a beautiful cream-colored structure with a Norman flavor, which was completed in 1929, at the north end of the beach. It had 30 bedrooms and sitting rooms and a huge garage, which made into a weekend bachelor house with room for 40. Unfortunately, the 1938 hurricane destroyed the structure, as it did most other beach facilities. [Pub. Green's Art Store, Narragansett, Rhode Island.]

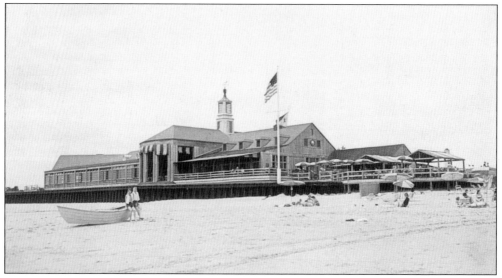

THE DUNES CLUB, C. 1940. Following its destruction in 1938, the club built a sturdier structure (shown above). At one time the membership included 750 families; a bathhouse with 250 lockers and 67 cabanas graced the extensive grounds. Summer society came from New York, Philadelphia, St. Louis, and Washington. The present Dunes Club was partially rebuilt following a battering by the 1954 hurricane. [Pub. Berger Bros., Providence, Rhode Island.]

40

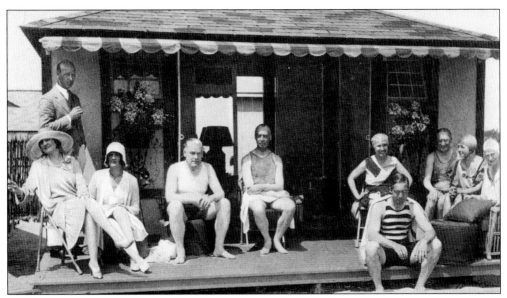

CABANA AT DUNES CLUB, C. 1930. This postcard is a rare close-up of Dunes Club society. The caption on the backside reads: "Mr. Peter A. Porter Jr., Cabana at Dunes Club, Narragansett Pier, Rhode Island." Mr. Porter probably had a small number of postcards produced for family and friends. The fine detail of the image provides some insight to the style and customs of cabana life. [Pub. The Abertype Co. Brooklyn, New York.]

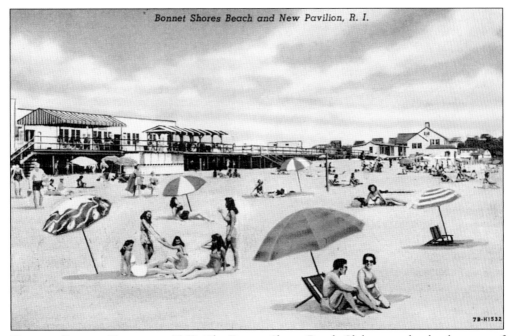

BONNET SHORES BEACH, C. 1940. The Bonnet Shores Beach Club was to be the showcase of a new resort development at Bonnet Shores. The 1,600-foot curving white sandy beach attracted many subscribers to a newly constructed pavilion. Unfortunately, the 1954 hurricane did extensive damage to the beach pavilion and adjoining cabanas, mandating reconstruction. [Pub. Narragansett Gift Centre, Narragansett, Rhode Island.]

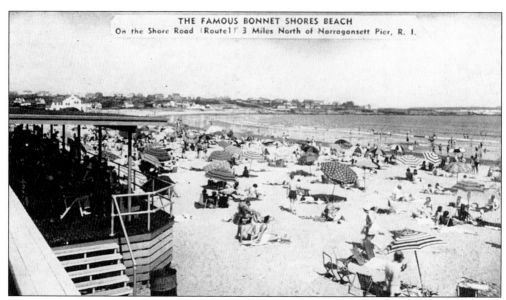

THE FAMOUS BONNET SHORES BEACH, C. 1941. The caption on the card back reads: "The famous Bonnet Shores Beach showing bathers enjoying beach and ocean recreation. Beach club deck is in foreground; in the distance a portion of the 600-acre residential development on Shore Road (Route 1), 3-miles north of Narragansett, Rhode Island." [Pub. H.K. Skinner, Pearl River, New York.]

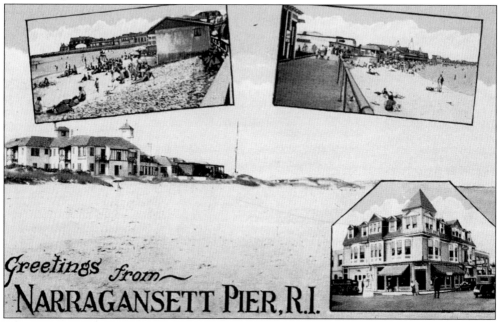

GREETINGS FROM NARRAGANSETT PIER, C. 1930. "By the way, I wonder if we Rhode Islanders really appreciate the outstanding natural asset which Narragansett Pier displays with its wonderful beach, one of the finest on the Atlantic Coast, its splendid Dunes Club with the dominating jovial personality of Howard L. Hitchcock at the helm—real Rhode Island, good for the health and good for the soul" (*Narragansett Times*, 1931). [Pub. House of a Thousand Gifts, Providence, Rhode Island.]

Three

HOTEL HERITAGE

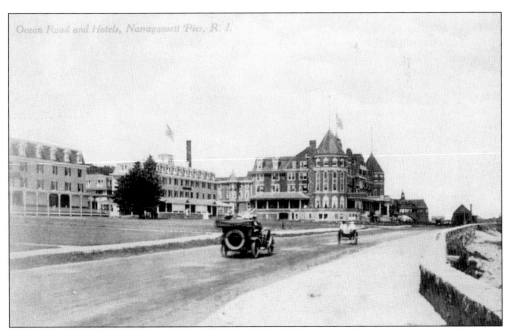

OCEAN ROAD AND HOTELS, C. 1910. Ocean Road became the status location for a long line of Victorian hotels that mushroomed at the Pier during its "Golden Era." Shown, from left to right, are the Atwood, Atlantic, and Mathewson Hotels. Their location near the Narragansett Casino and beach formed the early character of the Pier as a seaside hotel resort. [Pub. H.A. Dickerman & Sons, Taunton, Massachusetts.]

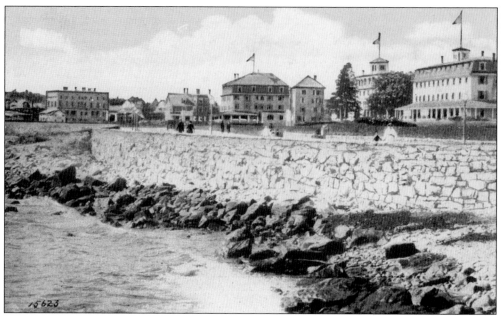

HOTELS, c. 1910. Ocean Road looking south, from right to left, shows the Atlantic, the Atwood, the Revere, and the Carlton Hotels. In 1902, the Continental was moved from Ocean Road to Beach Street, signaling the changing character of the Pier. Growing numbers of "cottages" and the advent of the automobile combined to push the grand hotels into steady decline. [Pub. Morris Berman, New Haven, Connecticut.]

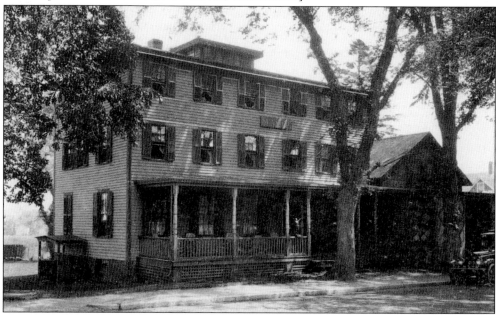

THE SEA VIEW HOTEL, c. 1912. Built in 1859 by John Eslick on Kingstown Road, this modest structure stands in sharp contrast to the large Victorian hotels. For over 100 years, it did not change names or fall victim to fire. Its size and simplicity allowed subtle change with the times; it became a rooming house and small store serving year-round customers. Urban renewal finally claimed the Sea View in 1971. [Pub. Green's Art Store, Narragansett, Rhode Island.]

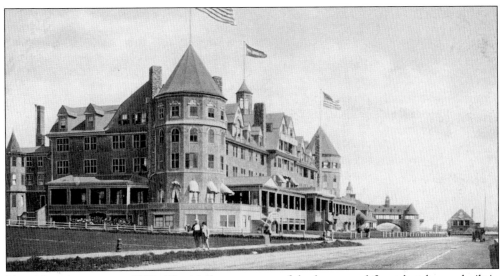

THE MATHEWSON, C. 1898. The Mathewson, one of the largest and finest hotels, was built in 1868 for S.W. Mathewson. Located in a commanding location on Ocean Road, it was enlarged and improved several times to the configuration shown above. Boasting hot and cold, fresh and sea-water baths, this much photographed hotel represented all that was good about the "hotel era" in Narragansett. It also represented an enterprise that was unable to adapt to changing social and economic conditions. [Pub. Charles H. Seddon, Providence, Rhode Island.]

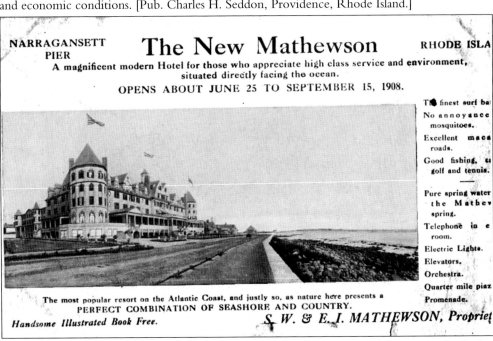

THE NEW MATHEWSON, C. 1918. The use of postcards for advertising became popular during this period of time. The wealth of information incorporated on this card was designed to convince the hesitant visitor. The back of the card was divided so that both a short message and address could be included. Unfortunately, the Mathewson did not attract enough visitors and was torn down in 1919. The site of this grand hotel is now occupied by a number of contemporary homes. [Pub. S.W. and E.I. Mathewson, Narragansett, Rhode Island.]

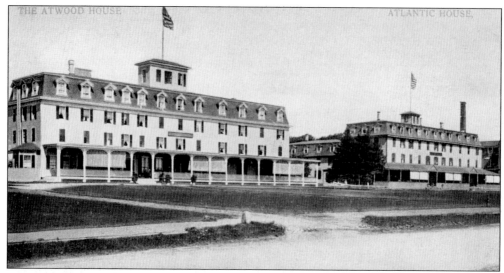

THE ATLANTIC HOUSE, C. 1895. The Atlantic House was built in 1867 by Abijah Browning and is pictured here with the Atwood (its near twin). Browning built the house with the intention of running a family hotel and was very successful. Its location at 85 Ocean Road assured constant patronage. Fire and hurricanes have battered the structure, but it still remains in altered form as the only remnant of the grand hotels. [Pub. A.C. Bosselman & Co., New York.]

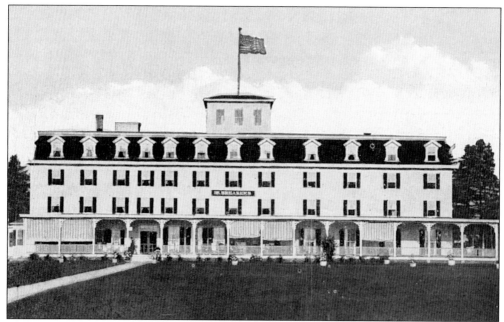

THE BREAKERS, C. 1910. Built in 1867 by Joshua C. Tucker, it was originally called the Atwood. Adjacent to the Atlantic, it was also successful for many years. The structure was 130 feet wide and could accommodate 200 guests. However, time and fate were not so kind to the Breakers; by the 1960s, it was empty and silent, and it was torn down in 1967. Today, condominiums occupy the site. [Pub. Tichnor Quality Views, Cambridge, Massachusetts.]

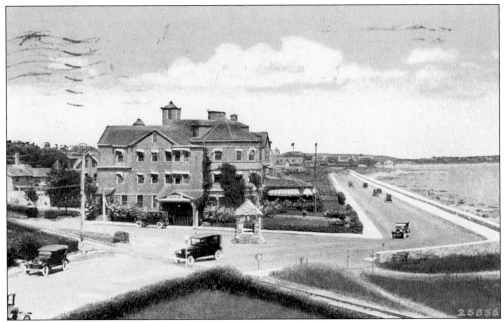

THE GREEN INN, C. 1915. Located on the corner of Ocean and South Pier Roads, the inn occupied the site of the old Southern Hotel. Built by H.W. Greene in 1888, the lovely inn was designed to "produce a hostelry, promising creature comforts found in English country inns" (*American Architect and Building News*, 1888). A large livery and boarding stable was constructed behind the inn, which was later converted to a parking garage to accommodate the automobile. [Pub. Berger Bros., Providence, Rhode Island.]

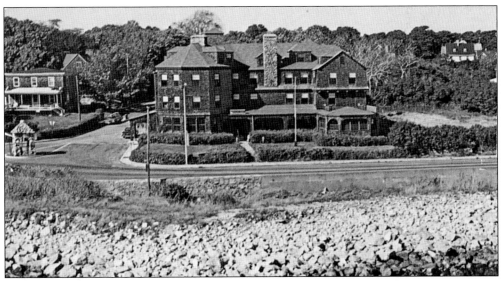

THE GREEN INN, C. 1970. After 80 years, the inn still maintained its distinctive English country charm. A solarium occupied the southeast corner with removable sash, which formed part of the verandah during the summer. The inn catered to the automobile enthusiast as well as a growing year-round population and was thus able to survive. However, in 1980 an early morning fire destroyed the wooden structure. [Pub. © L.K. Color Productions, Providence, Rhode Island.]

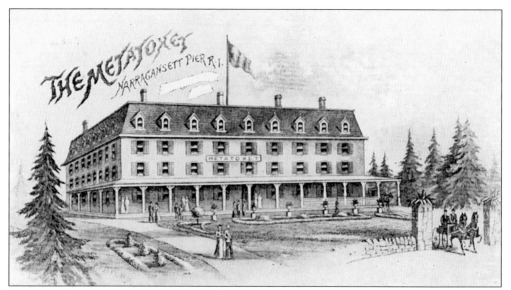

THE METATOXET, C. 1900. John H. Caswell built the Metatoxet in 1866–67. It was one of the early family hotels at the Pier and initially was only three stories with 29 rooms. The hotel was set back 300 feet from Kingstown Road and had a large elegant lawn and ample shade trees. It was sold to A.R. Edwards and renamed the European. [Pub. Anonymous.]

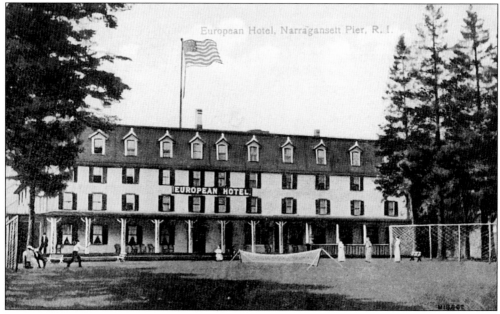

THE EUROPEAN HOTEL C. 1910. This postcard illustrates the change from a graphic to a photograph card. The Metatoxet had previously been enlarged and now advertises such amenities as lawn tennis. The name change was apparently an attempt to attract certain clientele with "European Plan" accommodations. [Pub. Rhode Island News Co., Providence, Rhode Island.]

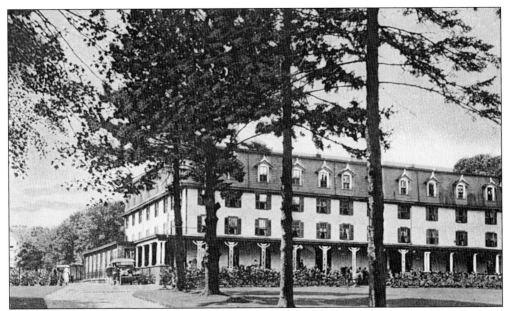

THE BEACHWOOD HOTEL c. 1920s. In 1920, Mr. and Mrs. George Wood purchased the European and renamed it the Beachwood. Elizabeth Wood, the daughter of Pier businessman Peleg Brown, and her husband, George, had previously operated the Pettaquamscutt Hotel. They successfully ran the Beachwood until 1936, when they retired. A fire in 1958 destroyed the hotel. The Beachwood Apartments now stand on the site at 30 Kingstown Road. [Pub. Tichnor Bros. Inc., Cambridge, Massachusetts.]

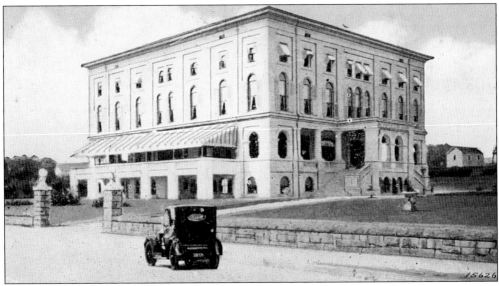

THE CARLTON HOTEL, c. 1929. This masonry structure was built by F.S. Kinney in 1895 on the former site of the Mount Hope Hotel. It served as his summer residence until his death and was known as Kinney Lodge. The property on Ocean Road was then purchased and remodeled to function as a hotel with A.F. Joy as its proprietor. Its unique construction proved durable; however, the economy did not, and it was torn down in 1968. [Pub. Morris Berman, New Haven, Connecticut.]

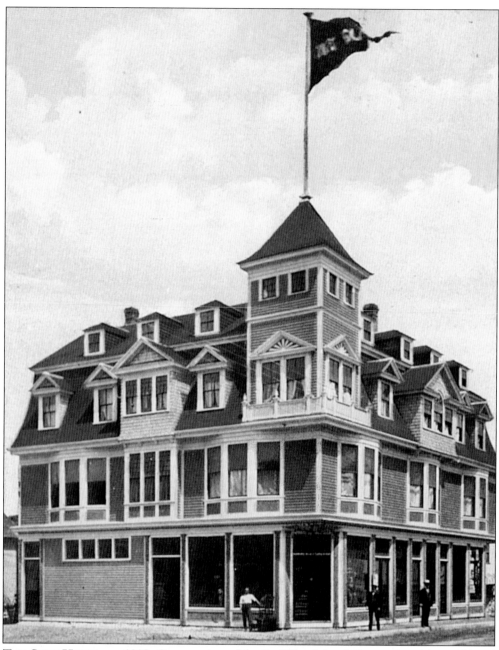

THE SURF HOTEL, C. 1903. Construction of the Surf Hotel signaled an end to the grand hotel era. With the advent of the automobile and continued growth of summer cottages, a smaller more versatile hostelry was needed. William H. Wolley located this turn-of-the-century hotel on the corner of Beach Street and Narragansett Avenue. "One of the largest business blocks at the Pier." Three commercial stores were on the first floor and 34 rooms on the remaining floors. It included "125 windows [and] a very fine view of the beach" (*Narragansett Times*, January 16, 1903). Modest additions accommodated a parking garage and other businesses. A survivor of hurricanes and fire, the landmark on Beach Street finally succumbed to the wrecking ball in 1972 as part of the town's urban renewal project. [Pub. Anonymous.]

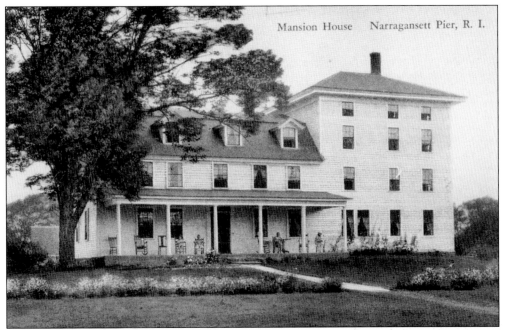

MANSION HOUSE, C. 1910. Early Visitors to the Pier were accommodated in farmhouses and cottages. Some of these were enlarged in response to the ever-increasing summer population. In 1866, Abijah Browning built an addition to the Watson farmhouse, which was one of the oldest in South County. Located on what is now Mansion Avenue between Kingstown Road and Narragansett Avenue, it was torn down in 1963 to make room for the Mansion Avenue Apartments. [Pub. Anonymous.]

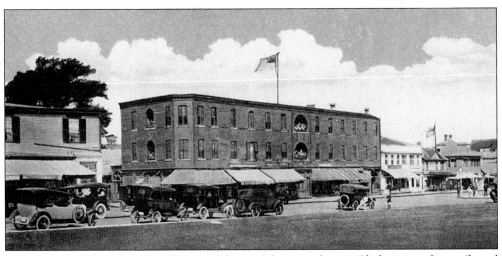

CLARKES, C. 1920. Located at the hub of the Pier's business district, Clarkes proved versatile and durable. It was constructed in 1890 with brick, iron, and stone. The three-story building contained businesses on the ground floor and 38 guestrooms on the upper floors. It was later renamed the Ocean View and was the site of some "gaming activities" that took place at the Pier. [Pub. House of a Thousand Gifts, Providence, Rhode Island.]

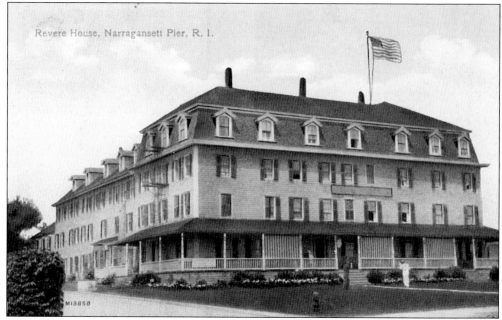

THE REVERE HOUSE, C. 1910. Captain James H. Rodman was one of the first to build a house in 1855 at the Pier for boarders. In 1868, Rodman built the Revere House on the corner of Ocean Road and Rodman Street. His original house was incorporated into the back of the new structure, which had a capacity for 150 guests and was known as a favorite of the New York visitors. It was destroyed by fire in 1928 and condominiums now occupy the site at 101 Ocean Road. [Pub. Rhode Island News Co., Providence, Rhode Island.]

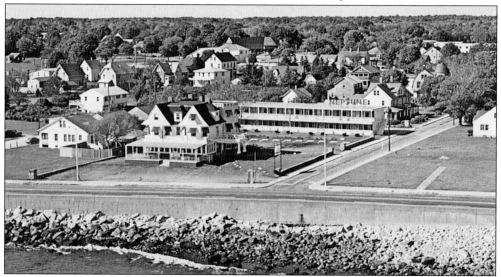

THE NEPTUNE INN, C. 1970. This aerial view of the intersection of Rodman Street and Ocean Road illustrates the changes taking place at the Pier after World War II. The Revere House once occupied the vacant lot on the right. Youghal Cottage on the left was modified in 1957 to become the Neptune Inn; a motel was also added. The establishment became the Pier House Inn and is currently known as the Ocean Rose Inn. [Pub. © L.K. Color Productions, Providence, Rhode Island.]

THE MASSASOIT HOTEL, C. 1915. This hotel was originally built for Edward Tucker on Narragansett Avenue. It was not successful and was taken over in 1877 by the bank, moved to Mathewson Street, and renamed the Massasoit. "The Hotel with its red carpeting and mid-Victorian decor, soon became the holder of an impeccable reputation catering mostly to elderly quiet vacationers" (*Narragansett Times*, March 11, 1971). In 1971, a fire, which started in a first-floor bedroom, quickly destroyed the hotel. [Pub. Morris Berrman, New Haven, Connecticut.]

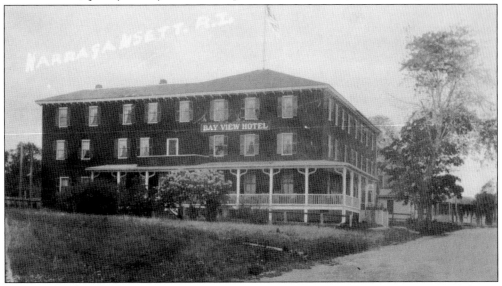

THE BAY VIEW HOTEL, C. 1920. This building was constructed in 1856 by Esbon S. Taylor on Ocean Road and called the Narragansett House. It was very successful, but was sold and moved to Congdon Street in 1888 and named Chandlers. It was later renamed the Ormsbee, then the Highland, and finally the Bay View. Serving as a rooming house and bar in its later years, the first hotel in Narragansett became one of the last before it was torn down in 1967. [Pub. Anonymous.]

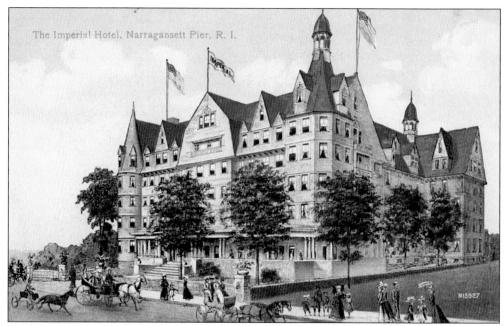

The **IMPERIAL HOTEL, c. 1900.** By name and appearance, the Imperial Hotel would seem more at home in Europe. It was built in 1899 by Walter A. Nye and became the most elegant hotel at the Pier. Nye purchased the Columbus Hotel, located on Central Street, in 1893 and promptly enlarged it. In 1898, he moved the Columbus back from the street where it became part of his distinctive new hotel. The rendering on this postcard is quite accurate and exhibits the hotel in a way that a photograph could not. [Pub. Rhode Island News Co., Providence, Rhode Island.]

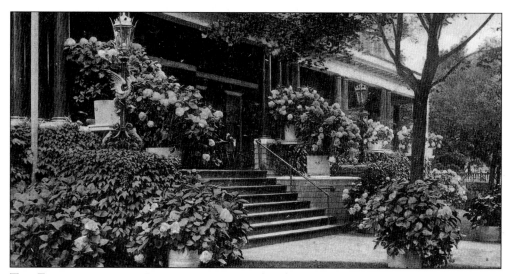

THE ENTRANCE TO THE IMPERIAL, c. 1900. This close up view of the entrance illustrates the fine detail of design and craftsmanship in Shingle-style construction. The six-story hotel was probably the most luxurious at the Pier and became the summer home of Narragansett's upper strata of society. Mr. Nye retired from the business in 1920 and sold the hotel. Unfortunately, it was destroyed in a spectacular fire in 1923. [Pub. Litho-Chrome # 11219.]

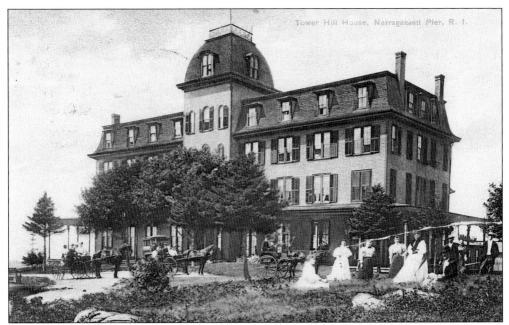

THE TOWER HILL HOUSE, C. 1892. This hotel opened in 1871 on Tower Hill about one mile west of the Pier. The complex included three cottages and 30 acres of fine lawn and beautiful shade trees. To accommodate guests, a unique "horse railroad" was constructed to the beach; this was not enough, however, to compete with the other hotels, and it closed in 1892. In 1931, it was acquired by the Catholic Diocese of Providence, and the Monsignor Clarke School currently occupies the site. [Pub. Rhode Island News Co., Providence, Rhode Island.]

THE PETTAQUAMSCUTT HOUSE, C. 1905. This family hotel was built in 1885 by Captain George N. Kenyon on 150 acres known as Little Neck Farm. Located near the Narrow River bridge between the beach and Pettaquamscutt Cove, the hotel had unobstructed views of water on three sides. For many years it was successfully managed by George Wood. In 1920, it was sold and torn down and replaced by a private residence. [Pub. Rhode Island News Co., Providence, Rhode Island.]

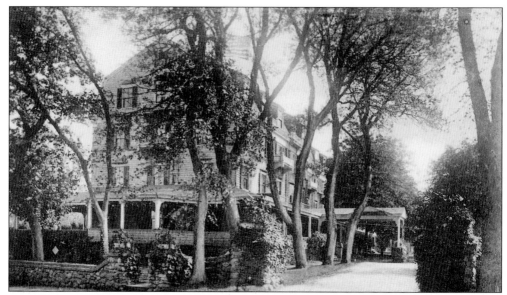

THE HOTEL GLADSTONE, C. 1907. The Gladstone was created in 1887 by George C. Robinson when he combined the adjacent Delavan and Elmwood Hotels. It was located on Kingstown Road between Mathewson Street and the Metatoxet Hotel. "One of the best appointed summer hotels in New England, has accommodations for 350 guests, is centrally located immediately adjoining the Casino and Bathing Beach" (*Narragansett Pier*, Rhode Island, Illustrated, 1891). [Pub. Anonymous.]

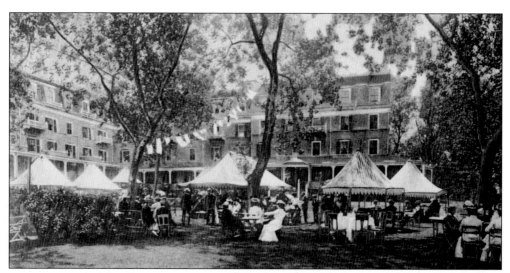

THE GLADSTONE HOTEL, C. 1902. The Casino Fire of 1900 left a large void in social facilities at the Pier. The Gladstone responded by creating the "Grecian Gardens" shown above. "Electric lights illuminated the gateways to the garden and encircled the colored canopies. On the gateposts are set baskets of flowers entwined with vines. A new bandstand was erected in the center . . . concerts rendered from 2:30 to 4:30 every afternoon and from 9:00 to 11:00 p.m." (*Narragansett Times*, July 11, 1902). The magic did not last, and like other large hotels, the Gladstone fell into decline in less than two decades. It was torn down in 1920. [Pub. A.C. Bosselman Co., New York.]

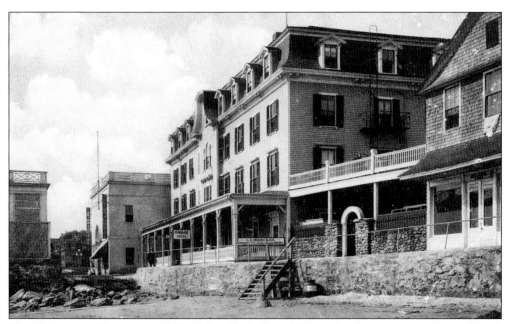

THE BURNSIDE HOUSE, c. 1917. Originally built in 1871 as the Continental on Ocean Road, it could accommodate nearly 200 guests. Following the great fire in 1900, hotel occupancy dropped and the Continental fell on hard times. Mr. J.G. Burns, whose Rockingham Hotel burned in 1900, purchased the Continental in 1902 and moved it more than one-half mile to the former site of the Rockingham annex. The structure was thoroughly refurbished and named the Burnside. It enjoyed the distinction of being the closest seaside hotel. [Pub. Green's Art Store, Boardwalk, Narragansett, Rhode Island.]

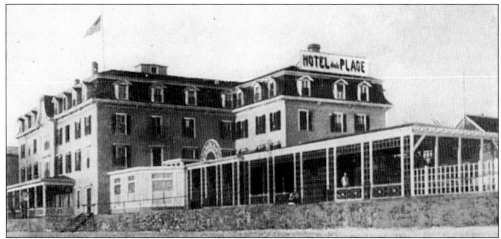

THE HOTEL DE LA PLAGE, c. 1921. The casual observer will see that the Burnside became the De La Plage. The Narragansett Improvement Association acquired the property in 1921 and thoroughly remodeled it with "just the proper foreign flair. Old buildings along the beach were torn down, and some potted palms placed about an enclosed garden next to the hotel, society was moving back" (*The Providence Sunday Journal*, February 17, 1935). The Town acquired title to the property in 1931, tore it down, and made a public park on the site. [Pub. Anonymous.]

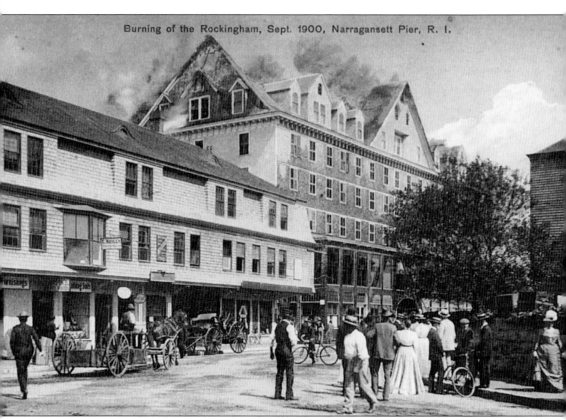

Burning of the Rockingham, Sept. 1900, Narragansett Pier, R. I.

THE ROCKINGHAM, C. 1900. This deceptively calm scene was captured by a photographer as fire broke through the roof of the Rockingham Hotel on September 12, 1900. The building on the left was the Hazard Block and at the right side of the picture a portion of the famous Narragansett Casino can be seen. All three structures were destroyed by the fire. The Rockingham started out in 1883 as the McSparran. It was enlarged several times, becoming "the largest, safest, newest, most commodious and elegantly appointed hotel of those among the New England summer resorts" (*New Rockingham Hotel Souvenir Booklet*, 1898). Broad piazzas fronted on the ocean, the bathing beach, and overlooked the casino directly across the street. The ballroom "is one of the most charming of the public rooms, being decorated in white and gold" (Ibid). The fire effectively ended the "hotel era" in Narragansett. The other grand hotels (the Mathewson, Gladstone, and Imperial) would carry on for another 10 to 20 years, but only the smaller hotels could cope with the coming social and economic changes. [Pub. D. Gillies Sons, Narragansett, Rhode Island.]

Four

THE NEW CASINO

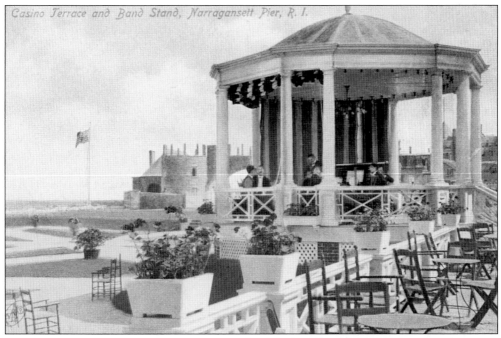

Casino Terrace and Band Stand, Narragansett Pier, R. I.

THE NEW CASINO BANDSTAND, C. 1905. Behind the bandstand looms the stone work remains of the old Narragansett Casino, which burned in 1900. Many thought the disastrous fire would mean the end of Narragansett Pier as one of the country's première summer resorts. However, influential summer residents such as Louis Sherry, John Hanan, and other locals would not let the Pier die so easily and planned a "New Casino" to usher in the new century. [Pub No. 7870, made in Germany.]

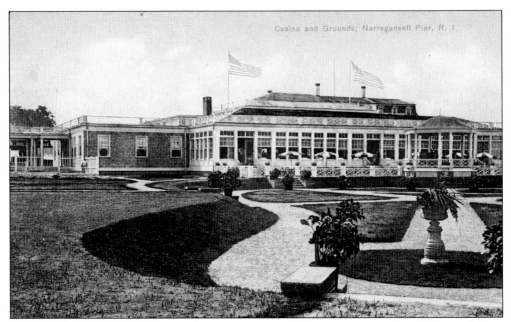

THE CASINO FROM ITS GARDENS, C. 1905. Designed by McKim, Mead, & White, architects of the old Narragansett Casino, the new structure displayed a distinctive Colonial style. The building proper was 100 by 200 feet in size with the main entrance on Exchange Place. Italian gardens, extending from the terrace to the bay, blended in with the architectural style. [Pub. Rhode Island News Co. Providence, Rhode Island.]

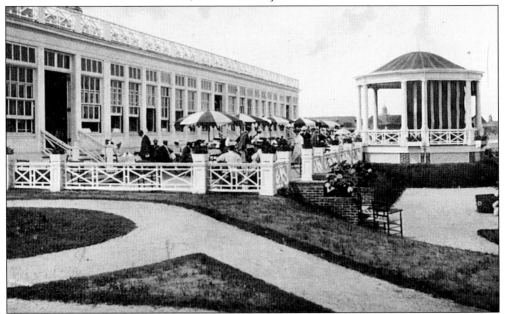

THE DINING TERRACE AND PAVILION, C. 1905. The terrace of the new casino was adjacent to the main dining room and extended 200 feet in length. An orchestra pavilion was arranged so that music could be enjoyed whether on the terrace or in the dining room. Two sets of stairs led down from the terrace to the gardens and beyond to the yacht landing. [Pub. A.C. Bosselman and Co., New York.]

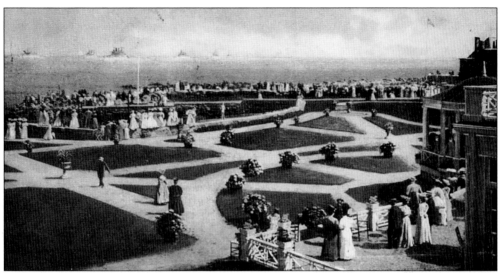

AMERICAN WARSHIPS FROM THE CASINO, C. 1906. The North Atlantic Squadron based at Newport held maneuvers off Narragansett every few years. Such an occasion occurred in 1906 drawing a large crowd of social elite at the casino grounds. Later in the day, there was "a sumptuous ball honoring Rear Adm. Robley (Fighting Bob) Evans at which Mrs. John Hanan, wife of one of the Casino company's original incorporators, led the grand march" (*The Providence Journal*, May 30, 1956). [Pub. Souvenir Post Card Co., New York.]

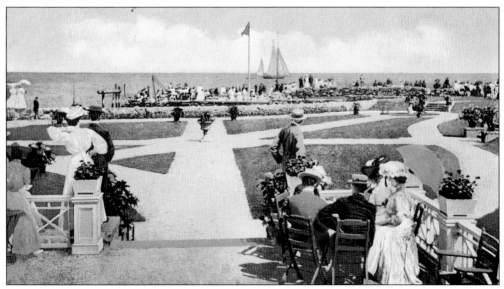

THE GROUNDS OF THE CASINO, C. 1905. The "garden layout will make such a complete transformation of this section of the Pier that one will feel that he is in a foreign land" (*Daily Times*, July 8, 1905). This afternoon scene shows some activity at the yacht landing. Launches from the yachts could land with safety and convenience. The depth of the water at low tide was at least 3 feet. [Pub. Rhode Island News Co., Providence, Rhode Island.]

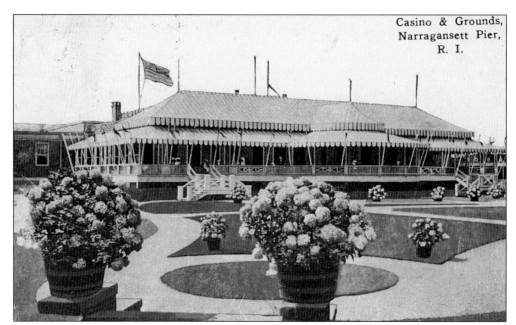

THE CASINO AND GROUNDS, C. 1908. The popularity of the new casino heralded a new era for the Pier. Additional space was soon needed. This was accomplished by extending the dining terrace and erecting a permanent canopy over the terrace and pavilion. It significantly changed the appearance of the casino, but added greater flexibility in its use of space during inclement weather. [Pub. Anonymous.]

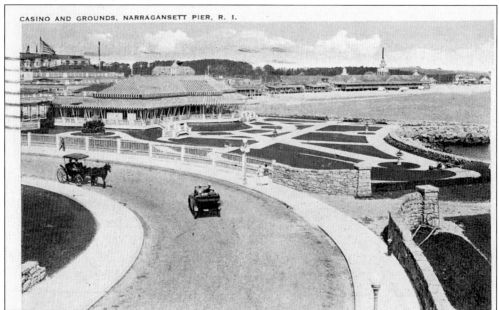

CASINO AND GROUNDS, NARRAGANSETT PIER, R. I.

THE CASINO AND GROUNDS, C. 1910. Viewed from the Towers, the new casino and grounds were an impressive sight. The Casino Company also widened Exchange Place to a width of 40 feet, eliminating a dangerous curve and providing sidewalks. Notice the beautiful stonework entrance to the yacht landing, the handsome street lights, and the Colonial fence, all of which enhanced the appearance of the grounds. [Pub. Louis Cuchon, Narragansett, Rhode Island.]

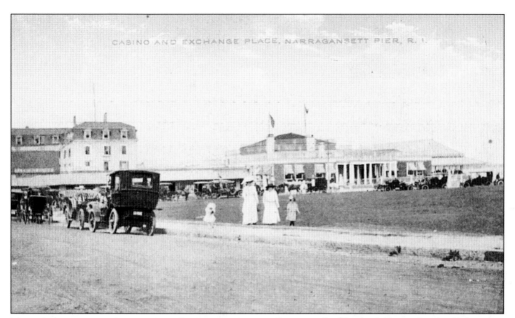

THE CASINO AND EXCHANGE PLACE, C. 1912. This view looking northeast from Mathewson Street shows the new casino's location on the grounds of the old Rockingham Hotel. The large four-story building on the left is the Burnside Hotel. The row of single story shops to the left of the casino was erected on the Hazard Block grounds following the fire of 1900. [Pub. Rhode Island News Co., Providence, Rhode Island.]

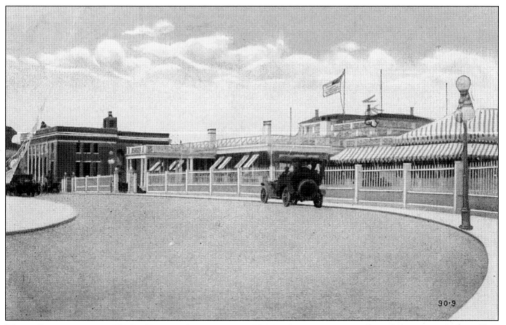

THE CASINO AND NEW POST OFFICE, C. 1915. Construction of a permanent post office building by the federal government next to the casino seemed like a good omen for the Pier. This view looking northwest clearly shows the fresh new face of Exchange Place. [Pub. Rhode Island News Co., Providence, Rhode Island.]

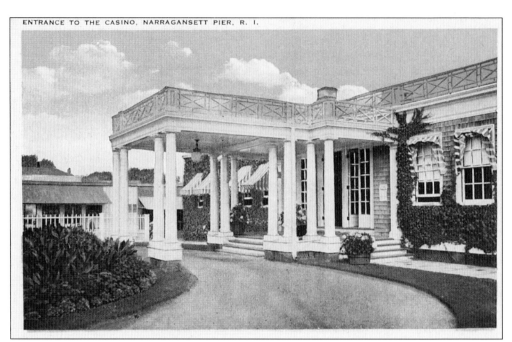

THE ENTRANCE TO THE CASINO, C. 1908. A closer view of the entrance reveals the details of the porte-cochere and railings. The front doors open into a wide hallway. On one side was the ladies' suite, which comprised writing, dressing, and coatrooms. On the other side was the gentlemen's writing room with a coatroom connecting. "The furnishings of the several rooms are simple and conform almost entirely with the lines of the interior" (*Daily Times*, July 8, 1905). [Pub. Louis Cuchon, Narragansett, Rhode Island.]

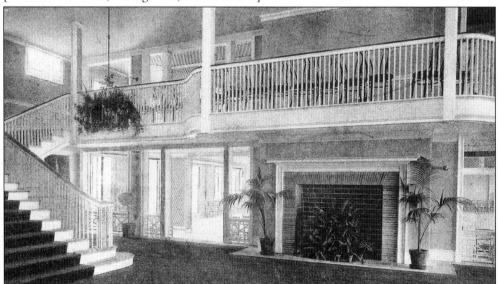

THE CASINO FOYER, C. 1908. The wide Colonial staircase lead to balconies, which extended entirely around the two-story ballroom. Underneath the balcony can be seen a large open fireplace. On either side of the fireplace were the main entrances to the ballroom. A red carpet covered the foyer, stairs, and halls. A large food preparation and storage area occupied the northwest portion of the building. [Pub. Litho-Chrome, Lepzig, Berlin, Dresden.)

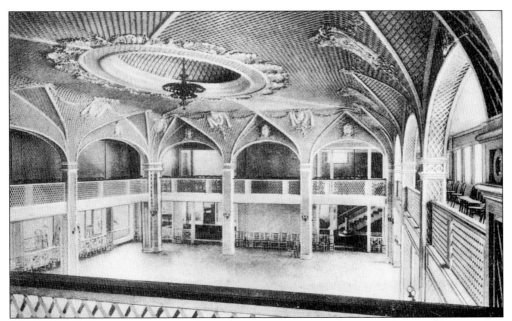

THE CASINO BALLROOM, C. 1905. The ballroom was 40 by 60 feet in size. Twelve columns supported the balcony and roof structure. "The room is entirely covered with lattice work painted white over a canvas background tinted pale blue. Over the center of the ballroom is a large elliptical dome" (*Daily Times*, July 8, 1905). The dance floor was maple; a large chandelier and sconces, each with a cluster of lights on the columns, provided lighting. [Pub. Green's Art Store, Narragansett, Rhode Island.]

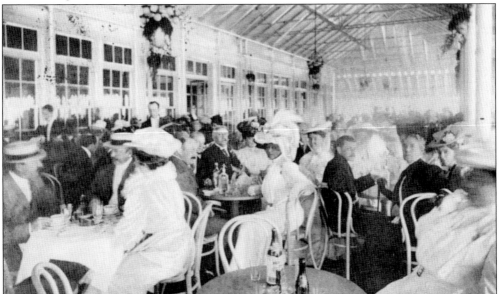

THE DINING TERRACE, C. 1908. An interior view shows the terrace after it was enclosed. The steel canopy structure is visible as are the windows separating the terrace from the main dining room, which was 25 feet wide by 120 feet long. The dining room was designed to serve about 400 at one time and just as many could be served on the terrace. [Pub. Rhode Island News Co., Berlin, Germany.]

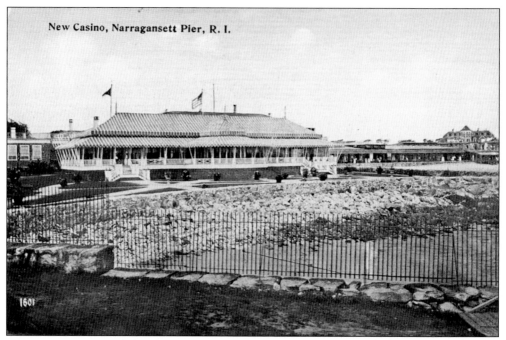

New Casino, Narragansett Pier, R. I.

THE NEW CASINO, C. 1912. Looking west from the yacht landing, the casino takes on the appearance of a giant circus tent. The sturdy iron fence in the foreground protected the unsuspecting or unwary from stumbling into the waters of Narragansett Bay. In the background at the far right is the four-story Surf Hotel. [Pub. Charles H. Seddon, Providence, Rhode Island.]

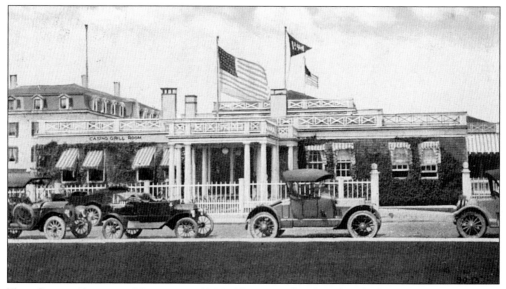

THE CASINO LOOKING NORTH, C. 1914. The original Colonial-style design is apparent in this view. Columns, railings, and wood trim were white while the exterior walls were cedar shingles. Inside was a small restaurant (grill) and private offices. The large kitchen facilities were located in the northwest section of the complex. [Pub. Morris Berman, New Haven, Connecticut.]

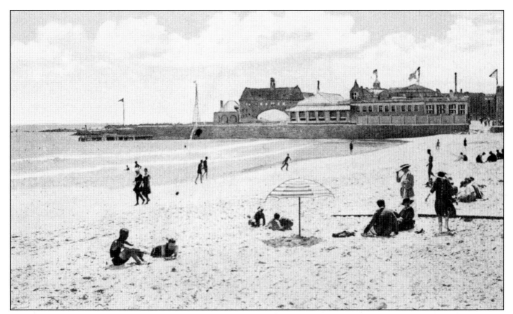

THE CASINO FROM THE BEACH, C. 1917. From the beach, the casino's silhouette is nestled in between the Towers and the new Casino Theatre. The dome-shaped roof over the ballroom is clearly visible as is the canopy covering the dining terrace and bandstand. The quiet appearance of the beach was probably due to the impact of World War I. [Pub. Louis Cuchon, Narragansett, Rhode Island.]

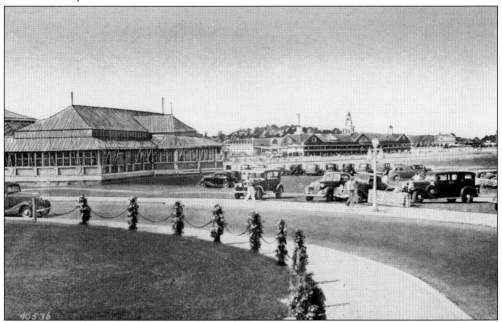

THE CASINO AND GROUNDS, C. 1930s. Hard surfaced highways connected all regions of the state to Narragansett. The casino and beach were still big attractions to the casual visitor but gone were the elegant Italian gardens, the Colonial fence, and much of the social way of life they represented. Symbolic of the changing times is the automobile parked on what use to be the Italian gardens. [Pub. Berger Brothers, Providence, Rhode Island.]

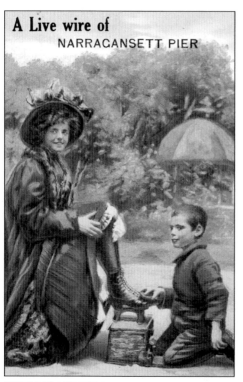

A Live wire of NARRAGANSETT PIER

A LIVE WIRE, C. 1912. The faster paced lifestyle at the Pier attracted many notables, some notorious for their antics. The *Narragansett Times* reported that Alice Roosevelt (daughter of President Roosevelt), who shocked the nation with her table top hoochy-koochy dance, sped through the Pier with Col. John Jacob Astor. Narragansett provided considerably more excitement than the staid social environment at Newport. [Pub Anonymous.]

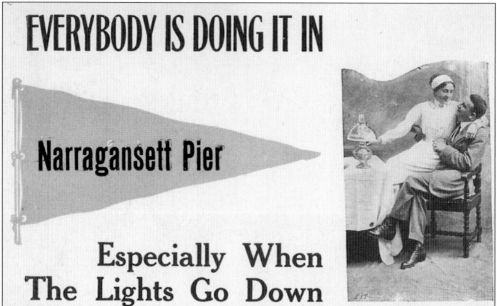

EVERYBODY IS DOING IT IN

Narragansett Pier

Especially When The Lights Go Down

EVERYBODY IS DOING IT, C. 1912. "Flag" postcards were popular in many resorts calling attention to a location with bawdy or catchy humor. It seemed fitting with the faster life style at the Pier. Visitors found more excitement than the beach, cotillions, and social teas. Episodes of gambling raids began to appear in the newspaper alongside the cottage directory and society columns. The postcard seemed to mirror the changes taking place at the Pier. [Pub. Anonymous.]

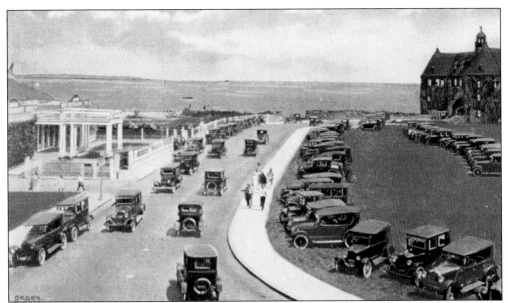

NEW AND OLD CASINOS, C. 1920s. The age of the motor car had a singular effect on the nature of Narragansett as a seaside resort. When automobiles became common, their owners began to dominate Narragansett and the old social order changed. When the new casino was designed, no thought was given to the automobile. In this scene, the old Narragansett Casino grounds have become a parking lot. [Pub. Berger Bros., Providence, Rhode Island.]

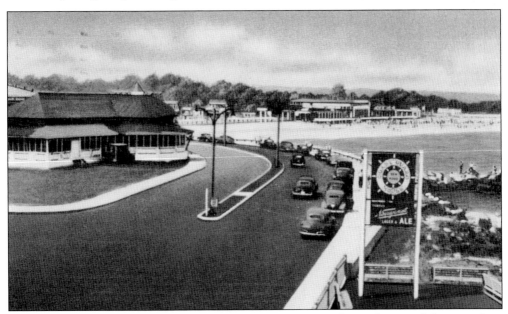

THE CASINO FROM THE TOWERS, C. 1946. The Hurricane of 1938 devastated the oceanfront at the Pier including the sea wall, Ocean Road, and all beach structures. The casino, though damaged, did survive. Ocean Road was realigned to pass around the north side of the casino, leaving the aging structure surrounded by roads. The sign in the right foreground advertises the Coast Guard Restaurant, which occupied the old Life Saving Station, now owned by the Bolster family. [Pub. Berger Bros., Providence, Rhode Island.]

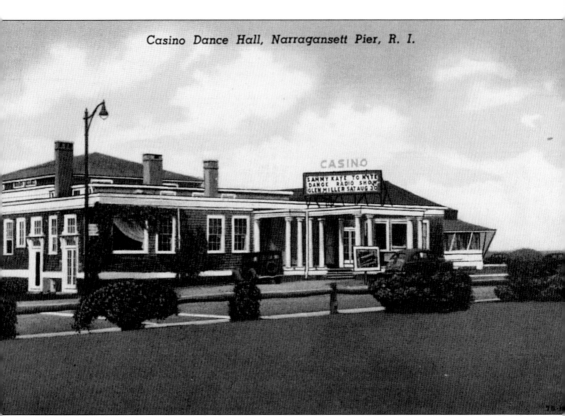

Casino Dance Hall, Narragansett Pier, R. I.

THE CASINO DANCE HALL, C. 1938. Dancing was very popular during the era of the big bands. The marquee reads "Sammy Kaye tonight, Glen Miller Sat. Aug. 30." The new casino, owned by John W. Miller since March 30, 1937, attracted big band names. Following World War II, it also attracted bowlers, pizza lovers, miniature golfers, and jitterbugs. Sadly, on May 30, 1956, a wind-driven fire destroyed the casino. Ironically, what remains today of the "Casino era" in Narragansett is the Towers spanning Ocean Road, which was the elegant entrance to the original casino, which burned in 1900. [Pub. Narragansett Gift Centre, Narragansett, Rhode Island.]

Five
GALILEE AND POINT JUDITH

Greetings from Narragansett Pier.

A FISHING BOAT OFF GALILEE, C. 1905. Generations of Point Judith fishermen have worked the waters of Point Judith Pond as well as the fishing grounds of Block Island Sound, Rhode Island Sound, and beyond to the edge of the continental shelf. Each year more than 66 million pounds of fish and shellfish are brought from the fishing grounds, through the breachway, to be unloaded at Galilee wharves and trucked to markets along the East Coast. [Pub. The Rotograph Co. New York City, New York.]

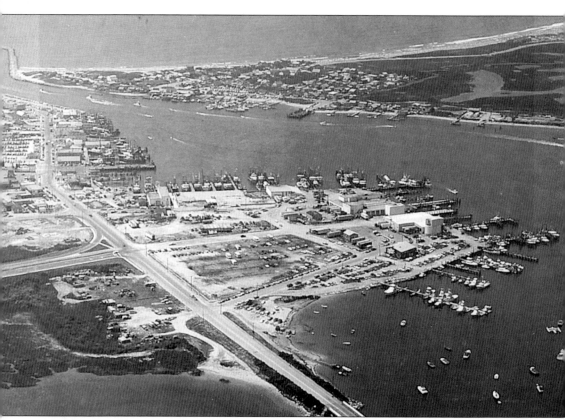

GALILEE AND JERUSALEM, C. 1970S. This aerial view to the southwest shows Galilee on the left, the breachway at upper left, and Jerusalem on the right. Galilee was named in 1902 when "Thomas Mann, a fisherman from Nova Scotia, who had settled here, felt the village that had sprung up with its fishing shacks should be called Galilee, after the fishing village of biblical times. One day the old timer sat on the docks repairing his nets when a stranger called out to him; Where am I? The answer was 'Galilee'. And 'what is that?' asked the stranger pointing to the other side of the channel. The old timer replied, 'must be Jerusalem'." And since that time, these names have been used to denote a most picturesque part of Rhode Island ("George's of Galilee," 1998). [Pub. Wilking Studio, Wakefield, Rhode Island.]

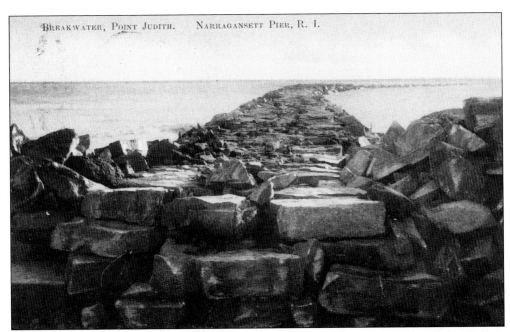

BREAKWATER, C. 1925. The Harbor of Refuge was created by constructing a 2.5-mile-long system of breakwaters extending west from Point Judith to the breachway of Jerusalem. The work by the Army Corps of Engineers began in 1898, but was not completed until 1907. It provided an artificial harbor along one of the busiest sea-lanes in the country. Countless ships have used the harbor to ride out a storm or rough seas. [Pub. Anonymous.]

THE VILLAGE OF GALILEE, C. 1935. The early development of Galilee included these buildings just inside the breachway. Champlin's Fish Market is on the left. The house in the center belonged to Ned Lillibridge, and the structure on the right to George Partelow. Partelow's became George's in 1948. This was a rather humble beginning for what has become an important fishing port. [Pub Berger Brothers, Providence, Rhode Island.]

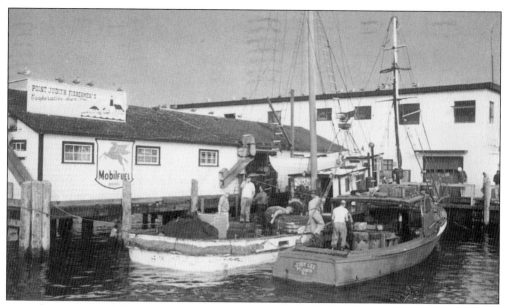

THE POINT JUDITH FISHERMAN'S COOPERATIVE, C. 1950S. In 1948, commercial fisherman from the port of Galilee formed an association that pooled their catches, processed and marketed the fish, and provided marine supplies to individual boat owners. The cooperative was a model of design and operation that provided great benefits to its members and has been a major influence in making Galilee a thriving fishing port. [Pub. Frank Desmaris, Pawtucket, Rhode Island.]

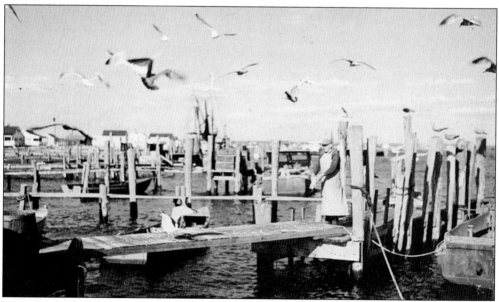

FEEDING THE SEAGULLS, C. 1950. Earnest (Skip) Streeter, owner of "Skip's Dock" in Jerusalem, feeds the seagulls with fish scraps. The veteran fisherman became a local legend when he and a 17-year-old helper were caught out in the middle of Point Judith Pond in a 15-foot-skiff during the 1938 hurricane. He rode out the storm by securing a line to a large downed oak tree. The next morning he returned to what was left of Galilee and Jerusalem to the astonishment of other survivors. [Pub. Photo Shop, Westerly, Rhode Island.]

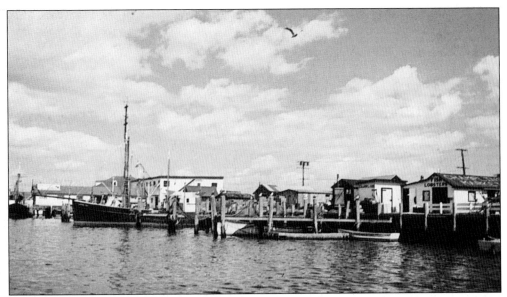

GALILEE, C. 1950S. This is a boatman's view of Galilee as you pass through the breachway. The Point Judith Fisherman's Cooperative building is at the left of picture. Champlin's Fish Market is at far right. To its left is Joe Whaley's fishing shack, followed by Carl Wescott's shack. Today, large permanent buildings occupy the same space. [Pub. Alman's Photo Supply, Wakefield, Rhode Island.]

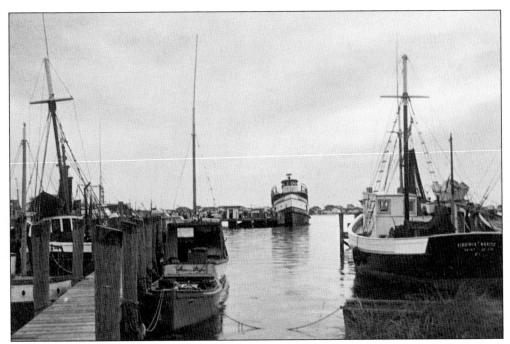

DUSK AT GALILEE, C. 1950S. The caption on the back of this postcard reads: "Dust settles over the busy fishing port and finds the boats snugly berthed with the Block Island boat at the State Pier in the background." The fishing boat at right, the *Virginia Marise*, belonged to Joe Whaley. [Pub. Frank Desmarias, Pawtucket, Rhode Island.]

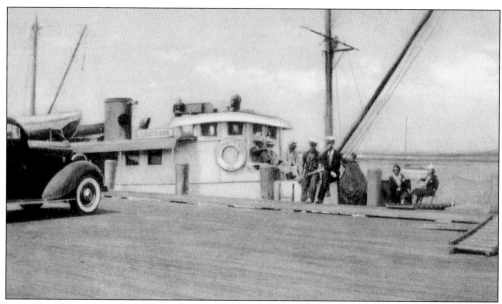

THE *ELIZABETH ANN*, C. 1937. The first regular ferry to connect Galilee to Block Island was the *Elizabeth Ann*. Owned by Interstate Navigation Co., the converted World War I submarine chaser served faithfully until 1951, when she burned at New London while undergoing a major overhaul. [Pub. Berger Brothers, Providence, Rhode Island.]

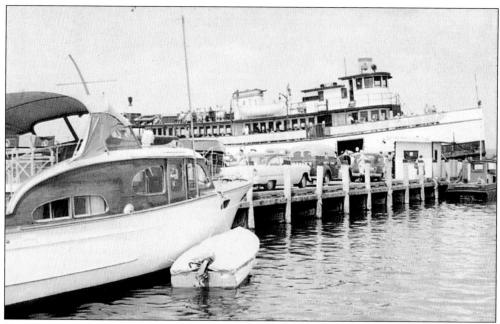

THE FERRY TERMINAL, C. 1957. The Block Island ferry *Yankee* awaits loading prior to its 12-mile passage from Galilee to Old Harbor, Block Island. The service is year-round and the sailing time is approximately one hour. The *Yankee* was originally built in 1907; after serving in two world wars, she began the Block Island run in 1957. [Pub. Frank Des Marais, Pawtucket, Rhode Island.]

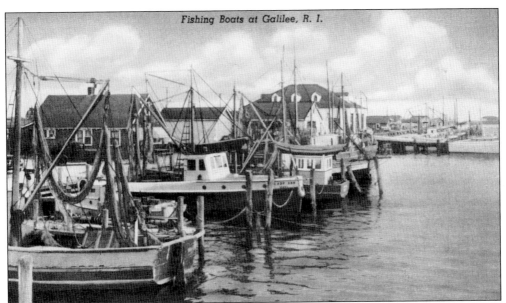

Fishing Boats at Galilee, R. I.

FISHING BOATS, C. 1950S. Looking south from the State Pier, a variety of boats and buildings are visible. The two-story building with a hip roof is the U.S. Coast Guard boathouse. Constructed in 1940, it houses three vessels and a nominal staff of ten. An earlier boathouse was built in 1933, but was destroyed by fire. It was then rebuilt in 1937, only to be destroyed by the 1938 hurricane. [Pub. Curteich-Chicago, Illinois.]

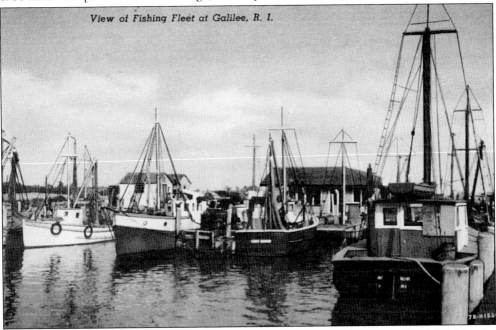

View of Fishing Fleet at Galilee, R. I.

THE FISHING FLEET, C. 1950S. A fortunate combination of forces have created a rich habitat for marine life in the waters surrounding Rhode Island. The great variety and abundance of finfish and shellfish have provided the Galilee fisherman with a sustained livelihood. Cod, bass, tautauog, flounder, scup, whiting, tuna, herring, bluefish, quid, lobster, scallop, oyster, and clams have all played a role in the development of Galilee. [Pub. Curteich-Chicago, IL.]

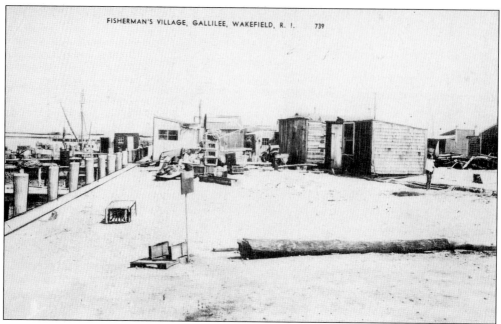

FISHERMAN'S VILLAGE, C. 1940s. The "fishing shack" was nearly as common as the fishing boat in a working fishing village such as Galilee. Most fishermen used small buildings to store supplies and gear. The Point Judith Fisherman's Cooperative reduced the need for fishing shacks and the subsequent growth of Galilee necessitated large permanent buildings to support its many and varied activities. [Pub. Anonymous.]

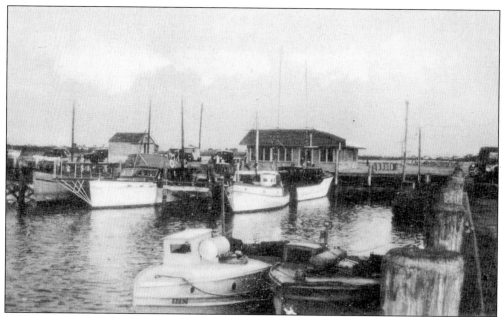

AT REST, C. 1940s. A collection of fishing boats are moored near the State Pier. The size and variety of boats found at Galilee attest to the rugged individualism of fisherman and the many different species of fish available in New England's rich marine waters. The unusual looking boat just visible at the bottom of the picture belonged to Herb Barnaby. [Pub. Anonymous.]

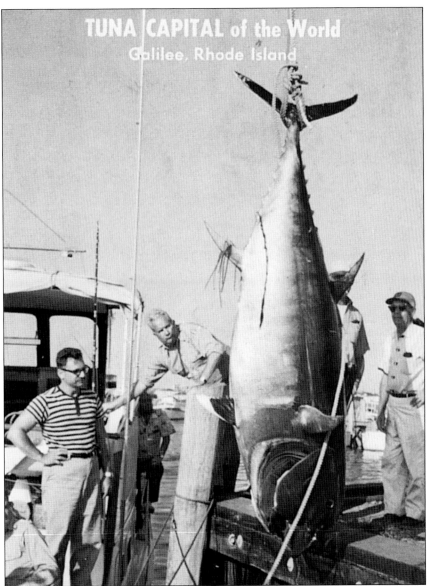

THE TUNA CAPITAL OF THE WORLD, C. 1960. "A quarter ton of fighting giant tuna being brought in at Galilee during the U.S. Atlantic Tuna Tournament," reads this postcard caption. Galilee became the home port for the U.S. Atlantic Tuna Tournament in 1953 and adopted the title "Tuna Capital of the World." The tournament was held in August and in 1956, 33 giant blue fin tuna, weighing approximately 9 tons, were landed. "More than 110 boats as far away as Florida, will compete for some of the most valued prizes in the world of deep sea sports fishing. Spectators will be swarming into the Galilee area from Saturday on with a total of over 150,000 expected by the end of next week" (*Narragansett Times*, August 8, 1957). The first fish of the 1957 tournament weighed 597 pounds. A giant tuna weighing over 1,000 pounds, caught during the 1980s, holds the tournament record. Galilee last hosted the U.S. Atlantic Tuna Tournament in 1972. It has since been hosted in fishing ports in Massachusetts, New Hampshire, and New York, as well as Block Island. [Pub © L.K. Color Productions, Providence, Rhode Island.]

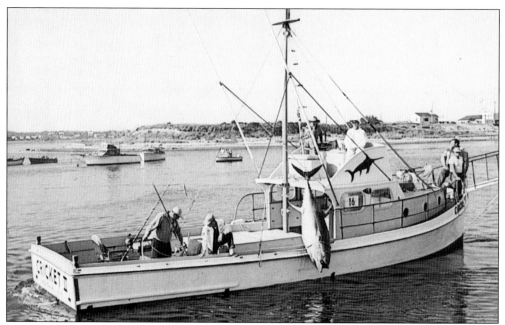

The Tuna Tournament, *c.* 1950s. The backside of this postcard reads: "Participating in the U.S. Atlantic Tuna Tournament is one of the leading contenders for top honors for the largest tuna." The Rhode Island Tuna Tournament has been held independently since 1957–58 and was last held in 1997. Restrictive quotas on giant tuna have been imposed by the National Marine Fisheries Services since the 1980s to protect the dwindling fishery. The future of these popular tournaments remains in doubt. [Pub. © L.K. Color Productions, Providence, Rhode Island.]

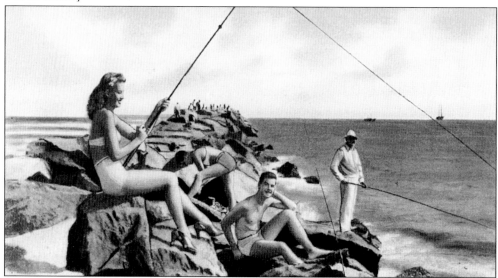

An Afternoon's Sport, *c.* 1950s. Fishing from the breachway jetty is good sport. However, it is unlikely the young lady walked there in high heels. The jetty is a massive stone structure 20 feet wide rising 10 feet above sea level. In the early 1900s, the Town of South Kingstown and the State of Rhode Island dredged the breachway to its present form and stabilized it with stone jetties. [Pub. Colorpicture Publications, Boston, Massachusetts.]

COTTAGES AT SAND HILL COVE, C. 1930. Sand Hill Cove is a long stretch of sandy shoreline extending west from Point Judith to Jerusalem. The Harbor of Refuge provided some protection from ocean storms, thereby attracting an increasing number of beach cottages. Constructed of wood and lightly framed, they were originally designed for summer use. [Pub. Anonymous.]

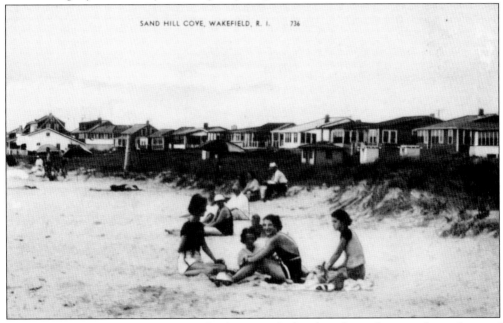

SAND HILL COVE, WAKEFIELD, R. I. 736

SAND HILL COVE, C. 1936. A happy family enjoys the beach in front of cottages located west of the breachway. The 1938 hurricane destroyed all of these cottages as well as most of those located east of the breachway. The tidal surge was so high it simply submerged the breakwater, allowing the huge waves to wash over the sand dunes. [Pub. American Art Post Card Co., Boston, Massachusetts.]

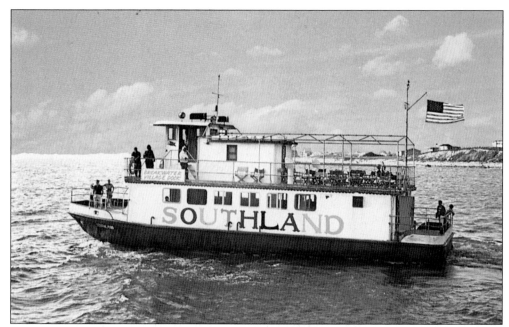

THE *SOUTHLAND*, C. 1970, THE "BEST SCENIC RIDE IN RHODE ISLAND." A popular way to see Point Judith Pond and the Harbor of Refuge is to climb aboard this 63-foot tour boat for a one hour and 45 minute cruise. The *Southland* holds 150 passengers and can be chartered for special occasions such as weddings and birthdays. Docked at the State Pier, it is enjoying its 28th season. [Pub. © L.K. Color Productions, Providence, Rhode Island.]

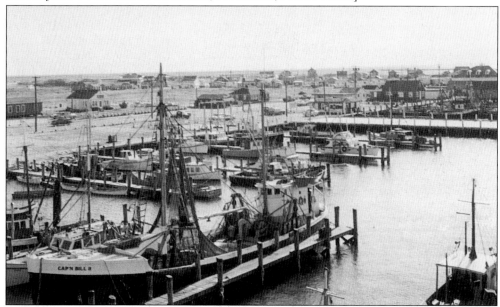

FISHING BOATS, C. 1950S. Galilee has been one of the most important commercial fishing centers in New England during the 20th century. Ranked just behind Gloucester and New Bedford, it grew steadily until the 1980s, when declining fish stocks reduced the number of active fishing boats. This view looking southeast shows the State Pier and a variety of water craft. [Pub. Almans Photo Supply Inc., Wakefield, Rhode Island.]

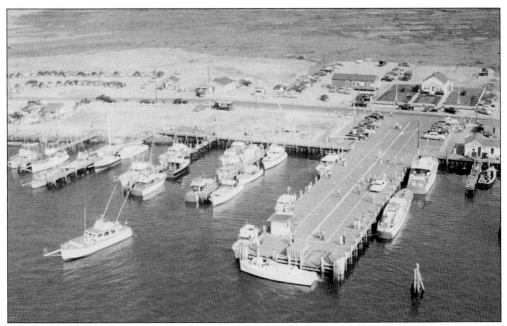

THE STATE PIER, C. 1950S. The State Pier has long been the center of activity at Galilee. The broad sturdy structure provides a terminal for the Block Island Ferry as well as mooring for visiting yachts. The harbor master's house can be clearly seen at the head of the pier, surrounded by lawn. [Pub. Almans Photo Supply Inc., Wakefield, Rhode Island.]

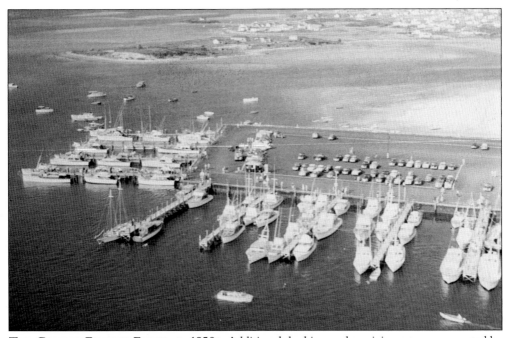

THE GALILEE FISHING FLEET, C. 1950S. Additional docking and servicing space was created by filling a marshy area north of the State Pier with dredge spoil. This view looking north shows Great Island in the background. Several fish processing facilities and a popular restaurant are now located in the area. [Pub. Alman's Photo Supply Inc., Wakefield, Rhode Island.]

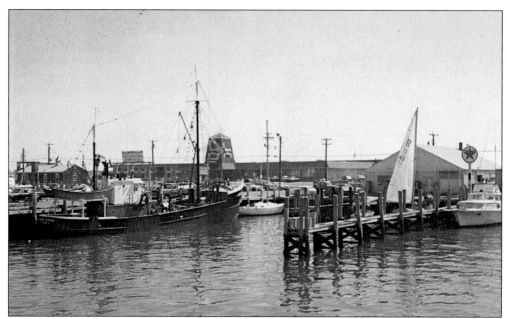

THE GALILEE FISHING VILLAGE. *c. 1972.* The caption on the back of this postcard reads: "This scene at the fishing port of Galilee shows the recently completed Dutch Inn adjacent to the water front." Galilee is not only a working fishing port but has also become a well-known tourist destination. [Pub. © L.K. Color Productions, Providence, Rhode Island.]

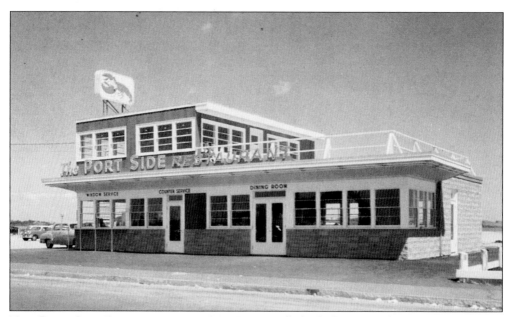

THE PORT SIDE RESTAURANT, *c. 1956.* Jim Petrella built the Port Side Restaurant in 1956 near the head of the State Pier. "A snack or seafood diner at the Port Side is a true adventure in the New England tradition of good food and surroundings," reads the caption on the back of the postcard. After a fire in 1972, the restaurant was enlarged and the top deck enclosed. [Pub. Aurora Postcard Co., Aurora, Missouri.]

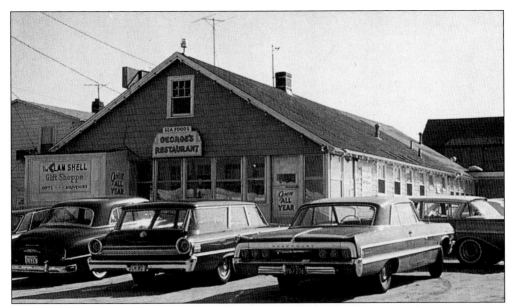

GEORGE'S OF GALILEE, C. 1960S. George's began in 1948 when Norman S. Durfee opened for business in a "small seafood shack." The establishment has grown into a fine nationally known restaurant. Conveniently located adjacent to the beach and breachway, it has become "Rhode Island's first choice for seafood" (George's brochure, 1998). The Durfee family still owns and operates the popular restaurant, which is open all year and can accommodate conferences, reunions, and holiday parties. [Pub. © L.K. Color Productions, Providence, Rhode Island.]

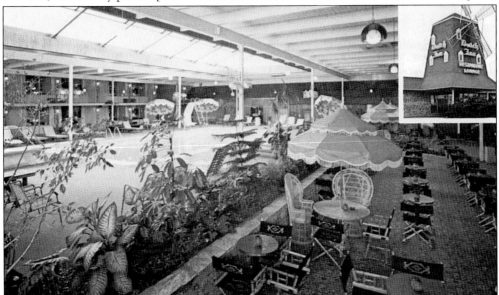

THE DUTCH INN, C. 1972. The inn, which was built in 1972, was designed to attract overnight visitors and represented a serious effort to diversify and strengthen the local economy. A full service facility, it featured a tropical setting for the colorful resident parrots and a large indoor swimming pool; also included were a hot tub, fitness room, and tennis courts, as well as a restaurant and bar. It now operates under the name "Lighthouse Inn." [Pub. D.A. Gunning Studios, North Providence, Rhode Island.]

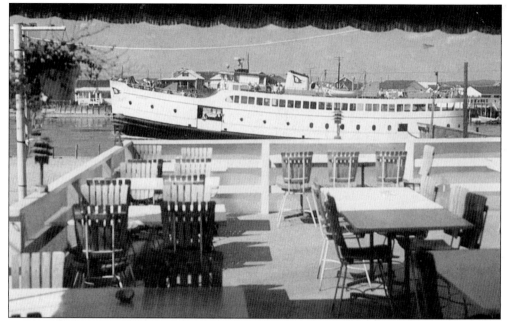

THE CHANNEL LOUNGE, C. 1959. "A magnificent view as seen from the sun deck of the Channel Lounge, located above George's Restaurant," reads the back of this postcard. This view catches the Block Island ferry *Quonset* passing through the breachway. The proximity of the lounge to the breachway and the size of the vessel provide a dramatic picture. [Pub. © L.K. Color Productions, Providence, Rhode Island.]

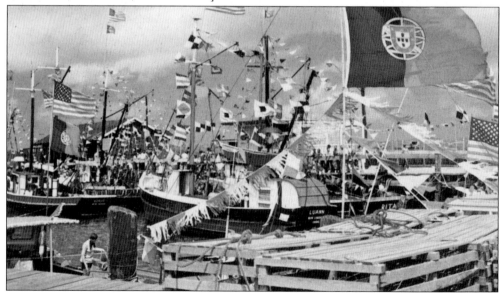

THE BLESSING OF THE FLEET, C. 1972. The annual "Blessing of the Fleet" attracts thousands of spectators to Galilee each year. Sponsored by the Narragansett Lions Club, the event is usually held on the last weekend in July. Scores of fishing boats and other watercraft are gaily decorated and "pass in review" through the Galilee breachway "where the fleet is blessed and services are held in remembrance of fishermen who were lost or died at sea" (Postcard Description). [Pub. The Book & Tackle Shop, Watch Hill, Rhode Island.]

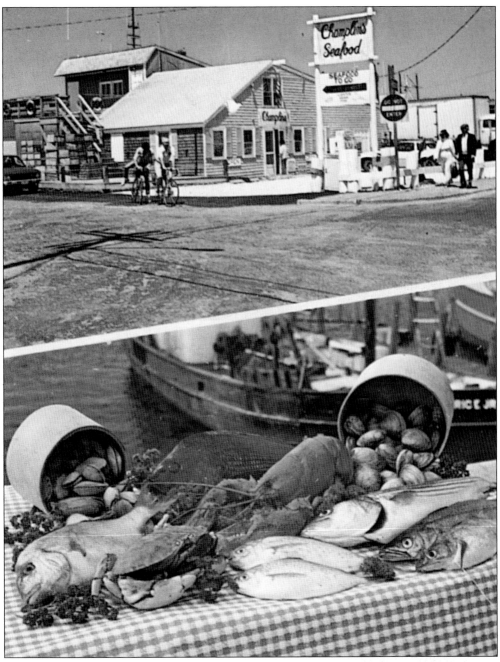

CHAMPLIN'S SEAFOOD, C. 1975. The oldest and perhaps the best-known establishment in Galilee, Champlin's Seafood began selling fresh fish in 1932 in a small one-room shack. Harry Champlin, the oldest of nine children and the brother of Leon "Brownie" Champlin (a legendary lobsterman who fished well into his 80s), started the market. Champlin's Seafood gained a reputation for the finest and freshest fish on the East Coast. The successful seafood market was expanded into a restaurant in the 1970s. "Eat on the open air deck so you can watch the local fishermen unloading their catch so you can toss an occasional clam to the seagulls for sport" (*Foder's Guidebook*, 1994). [Pub. Wilking Studio, Wakefield, Rhode Island.]

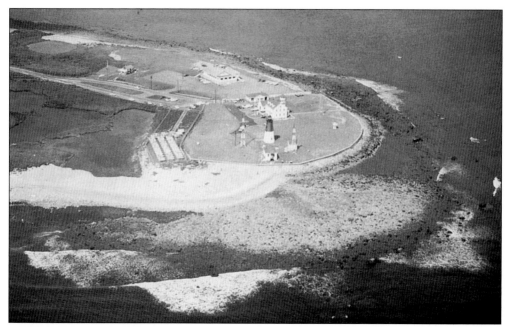

POINT JUDITH, C. 1960s. Often referred to as "Cape Hatteras of New England," Point Judith is surrounded by water with treacherous currents and a windswept rocky shore. The site was acquired in 1809 by the federal government from Hazard Knowles and a "light" was established in an effort to protect mariners. The postcard caption reads: "This aerial view shows Rhode Island's beautiful coastline at Block Island Sound and the Atlantic Ocean." [Pub. © L.K. Color Productions, Providence, Rhode Island.]

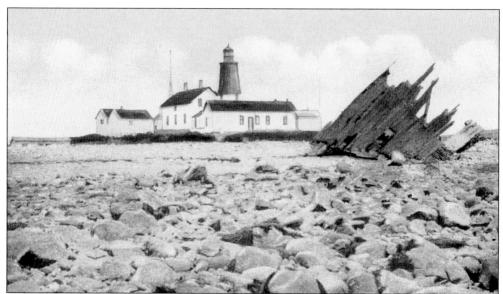

POINT JUDITH STATION, C. 1900. Point Judith has long been one of the most serious hazards to coastal shipping. Between 1893 and 1902, 92 vessels went aground on the treacherous rocks near the point. Men from the Life Saving Service patrolled the shoreline between Point Judith and Narragansett Pier. A halfway house for the patrols was located at Black Point. [Pub. Anonymous.]

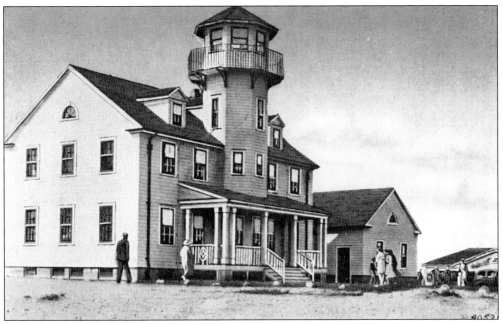

THE COAST GUARD AND LIFE SAVING STATION, C. 1939. In 1915, the U.S. Life Saving Service, which maintained a station at Point Judith, merged with the Coast Guard. A fire in 1933 destroyed the station and the building shown above was constructed in 1937. The Coast Guard Station at the Pier (now a restaurant) was vacated in 1938 and personnel were moved to this location. [Pub. Berger Bros., Providence, Rhode Island.]

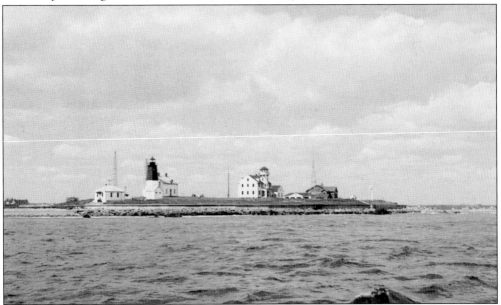

THE POINT JUDITH LIGHTHOUSE, C. 1960s. The first "light" was a crude wooden structure that was destroyed in the Gail of 1815. A second tower, 35 feet high and made of rough stone, was built in 1816. The present lighthouse dates from 1857 and is the third one on the site. It stands 65 feet above sea level and can be seen 17 miles out to sea. [Pub. The Book & Tackle Shop, Watch Hill, Rhode Island.]

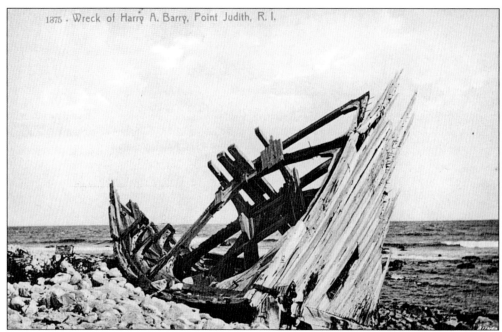

1875 - Wreck of Harry A. Barry, Point Judith, R. I.

THE WRECK OF THE *HARRY A. BARRY*, *C.* 1905. Known as the "Graveyard of the Atlantic," Point Judith attracted visitors just to view the battered hulls of wrecked coastal schooners. The *Harry A. Barry* went aground near the point in 1887. That same year crews of the Third District (Rhode Island and Long Island Sound) rescued "2,040 people from wrecks without the loss of a single life, a record that will probably never be equaled" (*Rhode Island: Genealogy-Biography, Vol. II*, 1908). [Pub O.P. Kenyon, Wakefield, Rhode Island.]

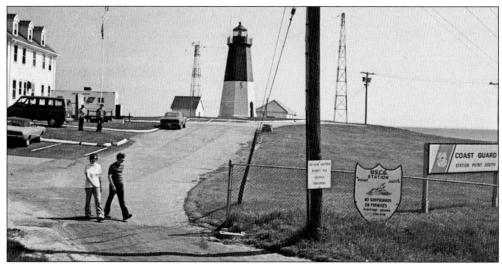

THE POINT JUDITH COAST GUARD STATION, *C.* 1960s. The lighthouse and Coast Guard station are familiar landmarks. The small one-story, gable-roofed building just to the left of the lighthouse was built in 1917 to store flammable liquids. The small one-story, hipped-roof building to the right of the lighthouse was built in 1923 and houses the fog horn's air compressor. The light was automated in 1954. [Pub. Book & Tackle Shop, Watch Hill, Rhode Island.]

Six

THE COTTAGES

A VIEW ALONG THE OCEANFRONT, C. 1912. The oceanfront cottages have come to symbolize the cottage era at the Pier. Many of the large estates were constructed in the early 1880s, foreshadowing the decline of the grand hotels. In 1883, 34 cottages were listed. In 1903, the list contained 106. "On the rocks, on the way to Point Judith, the places are far more spacious, and the houses are, many of them, not fairly to be termed cottages, even if none of them are sumptuous enough to vie with the marble palaces of Newport" (Brander Mathews, *Harper's Weekly*, 1906). [Pub. Rhode Island News Co., Providence, Rhode Island.]

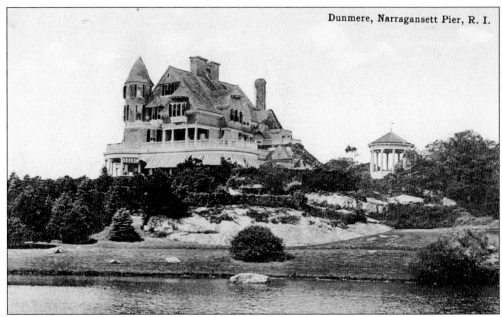

DUNMERE, *C.* 1900. Built in 1886 for Robert G. Dun (of Dun and Bradstreet), the Queen Anne-style mansion occupied a 13-acre estate on Ocean Road. This view from the ocean-side shows a man-made lake and gazebo set amid elegantly landscaped grounds. The mansion contained 30 rooms and was called the "showplace of the Pier." Also included on the estate were a large stable, two cottages, and a gatekeeper's house. [Pub. Anonymous.]

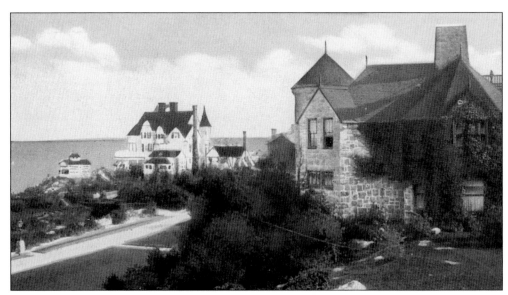

DUNMERE, *C.* 1908. This view looking toward the ocean shows the gatekeeper's house at right. Mr. Dun entertained the rich and the famous at Dunmere, including such notables as Chester A. Arthur, the 21st President of the United States. Mr. Dun died in 1900 and the estate was sold in 1913. A fire in 1929 destroyed the magnificent mansion. The stable and gatehouse have been tastefully converted into private residences. [Pub. Morris Berman, New Haven, Connecticut.]

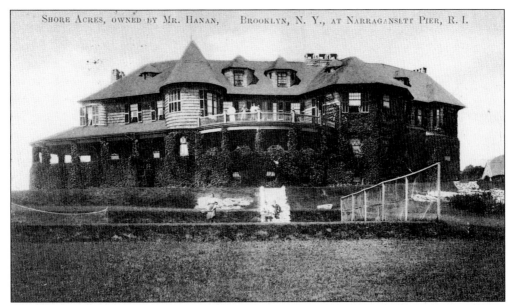

SHORE ACRES, OWNED BY MR. HANAN, BROOKLYN, N. Y., AT NARRAGANSETT PIER, R. I.

SHORE ACRES, C. 1909. Built in 1891 on Ocean Road for David Stevenson, it was originally called Suwanee Villa. "The site is one of the best at the Pier, commanding a vista from Block Island to far up the Bay" (*Narragansett Times*, July 17, 1891). Mr. and Mrs. John H. Hanan were married at Shore Acres in 1903 and occupied the home until 1920. It was the site of the Pier's most lavish parties. In 1966, the beautiful structure was torn down. [Pub. Anonymous.]

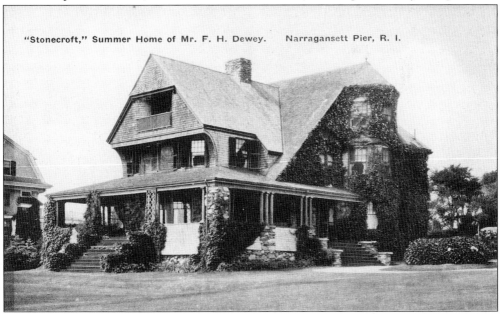

"Stonecroft," Summer Home of Mr. F. H. Dewey. Narragansett Pier, R. I.

STONECROFT, C. 1920S. This handsome Ocean Road cottage was built for Francis H. Dewey of Worcester, Massachusetts. A guest book entry from the 1920s reads: "many bright moments at Stonecroft we spend, when with the Deweys we have a week-end; we ride through the towns in their new Packard car, or sit on the porch when too hot to go far" (*Architectural Digest*, December 1998). Happily, this beautifully maintained home still serves as a year-round residence. [Pub. Green's Art Store, Narragansett, Rhode Island.]

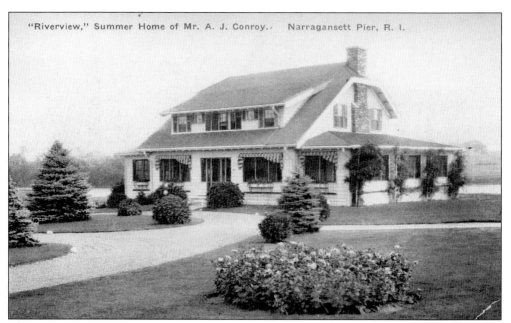

"Riverview," Summer Home of Mr. A. J. Conroy. Narragansett Pier, R. I.

RIVERVIEW, C. 1930S. This interesting summer home was built in the 1920s for Mr. A.J. Conroy. It exhibits both Shingle-style and bungalow-design elements, which reflect the changing mood of the period. Located on Boston Neck Road near "Narrow River," the home serves as a year-round private residence. [Pub. Green's Art Store, Narragansett, Rhode Island.]

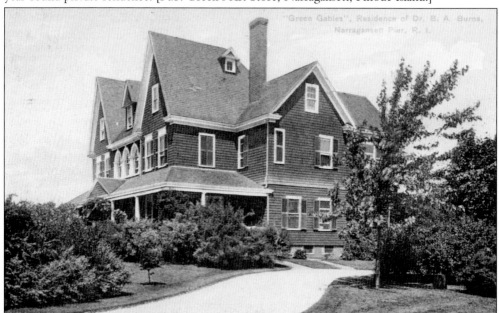

"Green Gables", Residence of Dr. B. A. Burns, Narragansett Pier, R. I.

GREEN GABLES, C. 1910. In 1902, Dr. Burt A. Burns built this stately home at 105 Central Street. "Mr. Burns believes that a cottage of the class that he has completed is of much benefit to a resort like the Pier" (*Narragansett Times*, June 13, 1902). The house measured 32 by 60 feet and included a large stained-glass window and mosaic floors. Six bedrooms were located on the second floor and six additional rooms on the third floor. Today, the home is a multi-family dwelling and is painted white. [Pub. Rhode Island News Co., Providence, Rhode Island.]

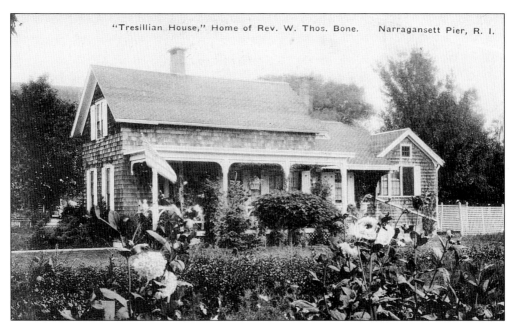

"Tresillian House," Home of Rev. W. Thos. Bone. Narragansett Pier, R. I.

THE TRESILLIAN HOUSE, C. 1910. This modest cottage was constructed in 1904 as a parsonage for the Baptist church on Caswell Street. Reverend W. Thomas Bone, who served as church pastor, occupied the house for many years. It is now a private residence at 108 Caswell Street. [Pub. Green's Art Store, Narragansett Pier, Rhode Island.]

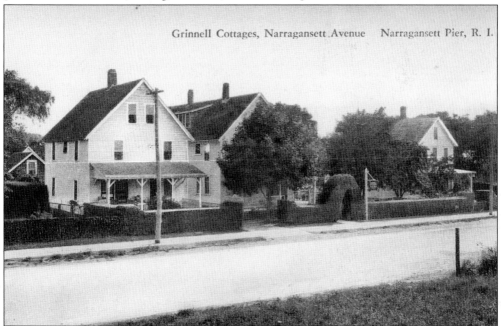

Grinnell Cottages, Narragansett Avenue Narragansett Pier, R. I.

THE GRINNELL COTTAGES, C. 1920. These three cottages were built over a period of years beginning in 1885 on Narragansett Avenue. In 1912, two cottages were joined to form "Peppers," which is reportedly the oldest continually operated restaurant in Narragansett. The cottages operate today as a "bed and breakfast," much the same as they did over 100 years ago. [Pub. Green's Art Store, Narragansett, Rhode Island.]

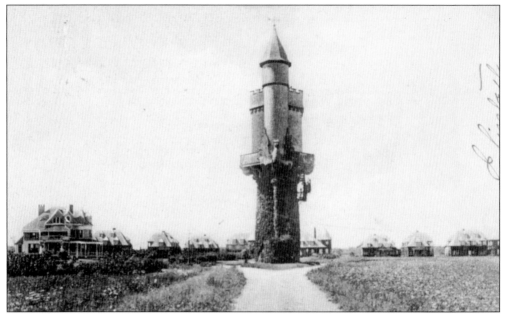

EARLE'S COURT, C. 1905. The ornate water tower and four cottages (one shown at the left of the picture) were built for Edward Earle in 1886–87. Mr. Earle was an influential summer resident and planned an extensive development. The other cottages shown were built for Louis Sherry on Gibson Avenue in 1888–89. Sherry's six cottages, designed in the distinctive "Swiss Moorish" style of architecture, formed a symmetrical compound and included a large restaurant called Sherry's Casino. [Pub. Retrograph Co., New York.]

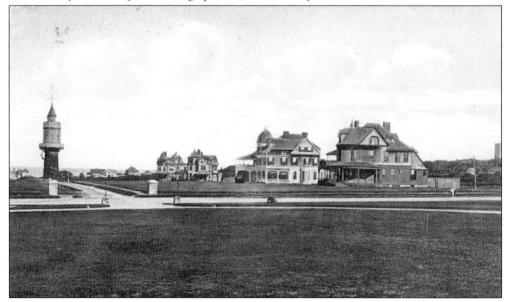

EARLE'S COURT COTTAGES, C. 1895. This view looking east from Kentara Green shows the four eclectic, late-Victorian cottages and water tower on Earle's Court. The development was significant because it illustrated a trend in the design and construction of an architecturally unified cluster of summer homes with shared common services. [Pub. Rhode Island News Co., Providence, Rhode Island.]

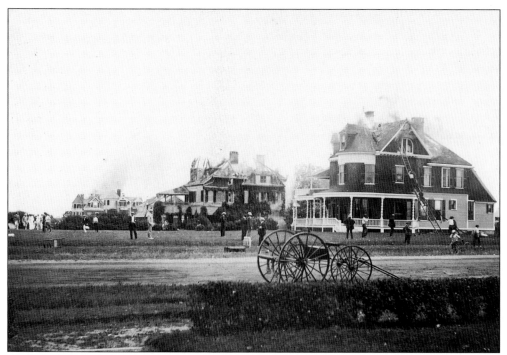

EARLE'S COURT ON FIRE, C. 1912. This unusual postcard captured the early stages of a disastrous fire that actually started in the kitchen at Sherry's Casino. After destroying the casino and three cottages, the fire crossed Gibson Avenue and burned three cottages on Earle's Court. Fire-fighting equipment of the day was out-classed by high winds and the rapidly spreading fire. [Pub. J.A. Hollingsworth, Narragansett, Rhode Island.]

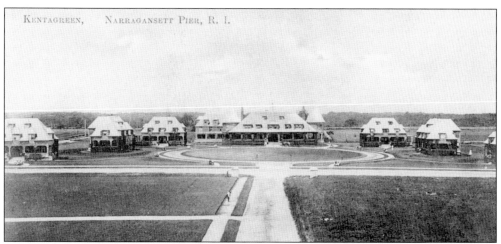

SHERRY'S COTTAGES ON KENTARA GREEN, C. 1895. Louis Sherry, a well-known New York restaurateur, turned to New York architects McKim, Mead, and White to transform his vision of a complex of cottages served by a central restaurant (Sherry's Casino) into reality. It became one of the first such developments in the country. Handsomely furnished and equipped with electric lights, the enterprise was very successful until the fire of 1912. One cottage was rebuilt in 1913. Today, the four remaining cottages serve as private residences. [Pub. A.C. Bosselman & Co., New York.]

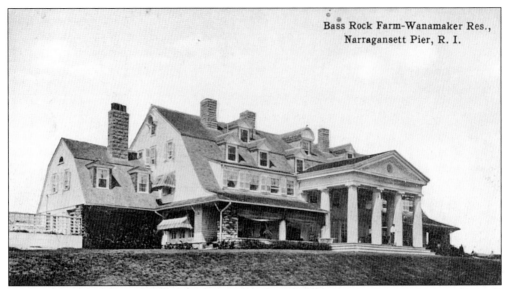

BASS ROCK FARM, C. 1914. Initially built in the late 1890s by John K. Brown for use as a hotel, it remained unfinished at the time of his death. In 1898, the estate was acquired by Thomas B. Wanamaker from Philadelphia. He completed the structure as a Colonial mansion with 40 rooms. In 1938, a raging fire destroyed what was once a "showplace of Narragansett." Contemporary homes now occupy the site on Ocean Road. [Pub. Pier News Co., Narragansett, Rhode Island.]

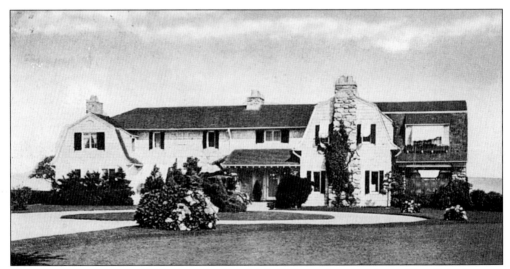

THE FELLS ESTATE, C. 1921. Dorothy Randolph Fells purchased a piece of her father's estate (Wild Field Farm) in 1913 and constructed this lovely Dutch Colonial cottage. Viewed from 460 Ocean Road, it exhibits the prominently placed fieldstone chimneys and gambrel roof. Beautifully maintained, it serves today as a private residence. [Pub. Anonymous.]

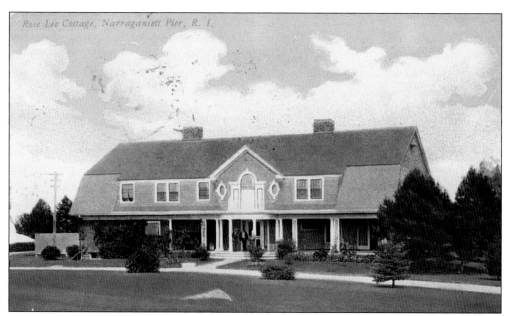

ROSE LEA, C. 1913. This Colonial Revival home was constructed in 1898 as a guest cottage on the estate of George V. Cresson (Stone Lea). It was designed by Willard Kent of Woonsocket and features Tuscan columns and Palladian windows on both front and rear sides of the home. Located at 410 Ocean Road, it is maintained as a private residence. [Pub. German American Postcard Co., Boston, Massachusetts.]

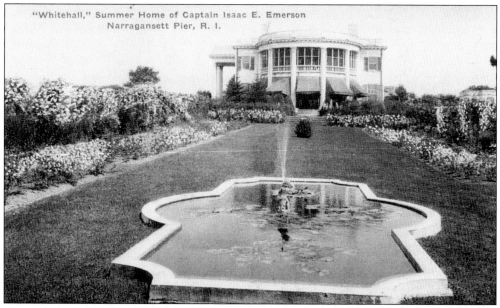

WHITE HALL, C. 1930S. This unusual view looking south displays White Hall's familiar columns and "Monticello" resemblance. It was built in 1917 for Isaac E. Emerson from Baltimore who patented "Bromo-Seltzer." The white brick-and-stucco mansion contained some 30 rooms and the 12-acre estate on Ocean Road included several other buildings. It was sold in 1947 and torn down in 1971 to make room for contemporary homes. [Pub. Green's Art Store, Narragansett, Rhode Island.]

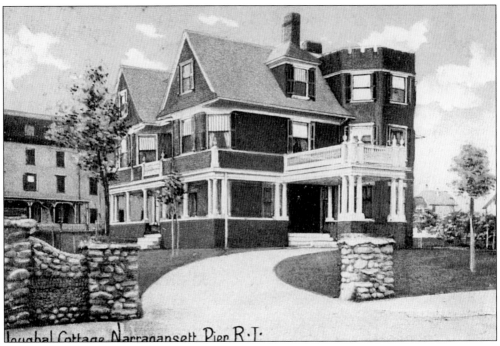

loughal Cottage Narragansett Pier R.I.

YOUGAL COTTAGE, C. 1901. Located on the corner of Ocean Road and Rodman, this summer home was built for Dr. James E. Sullivan of Providence. The structure at the left is the Continental Hotel, which appears vacant. It was moved in 1902 to a new location on the beach. Today the cottage has been remodeled into a commercial establishment known as the Ocean Rose Inn. [Pub. Louis Rubin, Providence, Rhode Island.]

ROCKLEDGE, C. 1900. In 1888, E. Harrison Sanford of New York built this prominent cottage on the "cliffs." The view looks southwest; the pathway (cliff-walk) is of particular interest along the shoreline. The public access ran between South Pier Road and Scarborough. Life saving crews walked the shore line path on their patrols from Scarborough to the Pier. This Ocean Road home was razed in the 1960s. [Pub. Morris Berman, New Haven, Connecticut.]

100

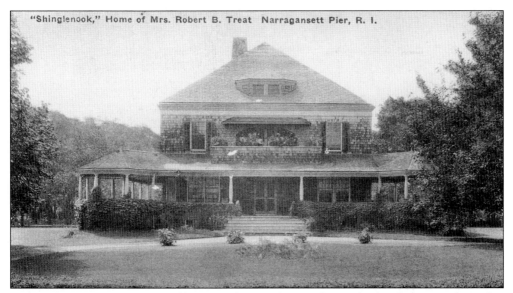

"Shinglenook," Home of Mrs. Robert B. Treat Narragansett Pier, R. I.

SHINGLE NOOK, C. 1920S. Built in 1887 for Brander Matthews, this lovely home is located at 50 Central Street. George A Freeman Jr. designed the summer home in the Shingle style. Matthews, a playwright, drama critic, and free lance writer, was a professor of literature at Columbia University and loved to summer at the Pier. He published a well-known article about Narragansett Pier in *Harper's Weekly* magazine in 1906. [Pub. Green's Art Store, Narragansett, Rhode Island.]

IDLEWILD, C. 1920S. Built in 1869 for Charles E. Boon, it was the first summer cottage erected at the Pier by a summer guest for their own use and enjoyment. Boon was a Providence businessman who later sold his interests in Providence, moved to the Pier, and became involved in real estate. In 1887, Idlewild was purchased by the Davis family of Providence. The house remains a private residence at 40 Central Street. [Pub. Anonymous.]

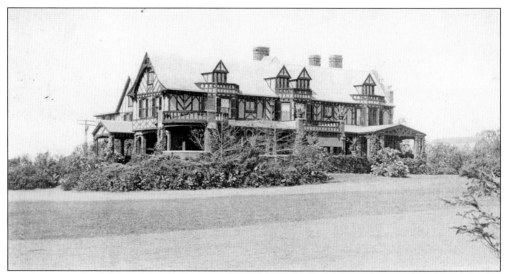

VALMAR, C. 1920. This beautiful English Tudor-style home was built around 1899 for Mrs. Emily F. Griggs. In 1902, it was sold to Samuel H. Valentine, who named it Valmar. "The estate was described as one of the finest places in Narragansett. A Japanese Tea room was added, being modeled after the style of a tea room in the house of a high Japanese official, the whole work being done by native Japanese, and is the only room of its kind in this country" (*Narragansett Times*, May 15, 1958). In 1958, a fire destroyed the home. [Pub. Anonymous.]

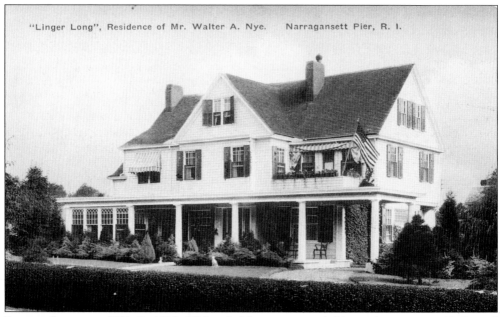

LINGER LONG, C. 1910. In 1890, Walter A. Nye constructed this stately cottage at 93 Central Street. Mr. Nye was a well-known hotel proprietor who ran the Gladstone and owned the Columbus and Imperial Hotels. He retired in 1920 as one of the most successful men in the business. Today, the home is maintained as a private residence. [Pub. Green's Art Store, Narragansett, Rhode Island.]

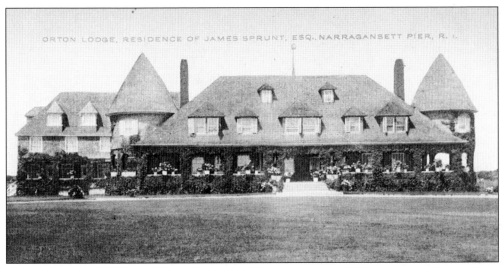

ORTON LODGE, C. 1900. Built in 1888–89 on Gibson Avenue for Louis Sherry, it was also known as "Sherry's Casino" or the "Little Casino." The structure served as a restaurant with public and private dining rooms, guestrooms, and private living quarters. In 1912, a fire broke out in the kitchen and quickly spread, destroying the casino and three other cottages in the complex. Trees and gardens now cover the site on the western portion of Kentara Green. [Pub. Rhode Island News Co., Providence, Rhode Island.]

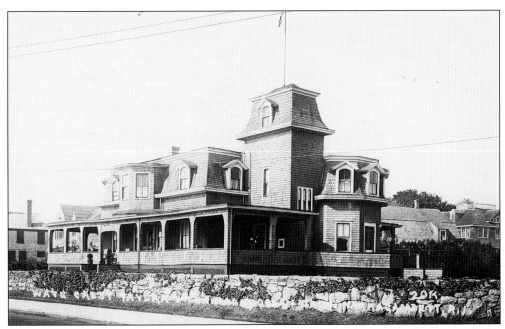

THE WAVE CREST TAVERN AND TEAROOM, C. 1912. Also known as "Sea Lawn," this structure was originally constructed in the 1870s on Mathewson Street as a "men's club" named the Reading Room. After the Narragansett Casino was built, it was moved to its present location on 41 Ocean Road, adjacent to the Towers. It subsequently became a private residence and the Lila Delman's Real Estate Office. [Pub. Eastern Illustrating Co., Belfast, Maine.]

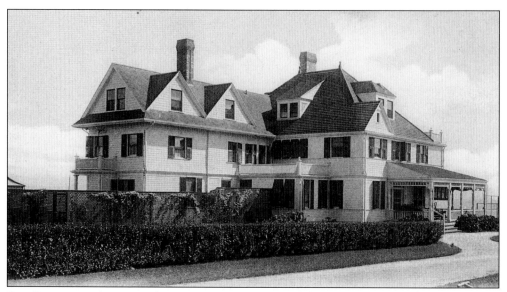

SEA BREEZE. Built in 1881 for Samual Colgate of Orange, New Jersey, this "villa" was one of the first summer homes built along the rugged coastline south of South Pier Road. The view is looking northeast toward the bay. In 1908, the property was purchased by Saunders P. Jones, who maintained the name "Sea Breeze" for several years. He later renamed it the Holiday House. [Pub. Anonymous.]

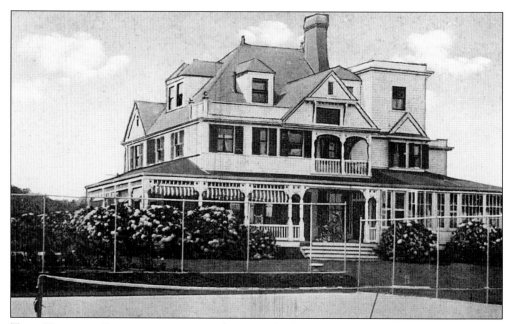

THE HOLIDAY HOUSE, C. 1930s. The view looks west from the shoreline. A careful comparison with the image at the top of the page reveals that the structures are the same with little modification except the name change, which was unusual. It was not unusual, however, for new owners after World War II to raze older structures and replace them with contemporary homes. This was the fate of the Holiday House in the 1950s. [Pub. Anonymous.]

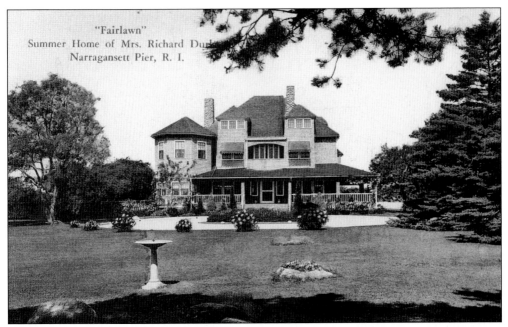

FAIRLAWN, C. 1920S. This distinctive summer home was designed by McKim, Mead, and White for Allan McLane of Washington, D.C. It was built in 1885–86 at a cost of $12,626. Located on the west side of Ocean Road at No. 415, it was originally called "Gillian Lodge." The twin three-story front pavilions and octagonal corner bay are easily recognized today in the private residence. [Pub. Green's Art Store, Narragansett, Rhode Island.]

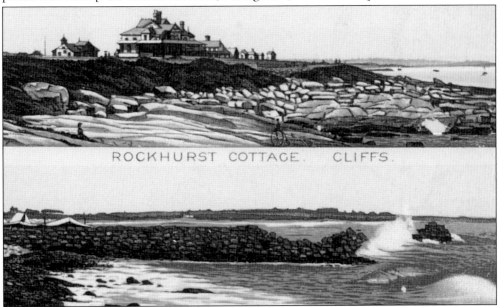

ROCKHURST, C. 1895. In 1880, William Gibbons Preston designed and built Rockhurst for Howard Lapsley, a New York banker. This was the first of a series of cottages along the "cliffs" on the former Hazard estate. In the 1920s, Rockhurst was moved several hundred feet south of its original location, however; it remains today a beautifully maintained private residence. [Pub. Anonymous.]

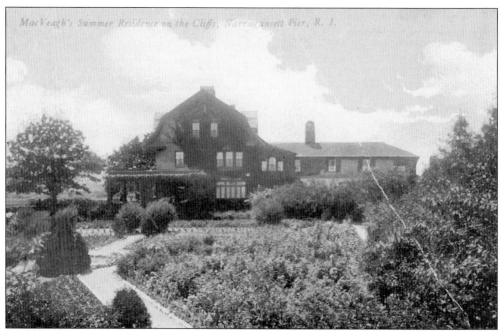

MCVEIGH'S, C. 1908. Charles McVeigh purchased a large Ocean Road estate known as "Anthony's." It was originally a guesthouse in the 1870–80s that catered to sportsmen, who loved to fish off the rugged rocks near Black Point. "On the rocks are numerous fishing stands bolted to the cliffs, where summer visitors enjoy bass fishing and often land fish weighing upward of 50 pounds" (*Souvenir Book*, Narragansett Pier, RI: Hotel Men's Association, 1891). [Pub. German American Postcard Co., Boston, Massachusetts.]

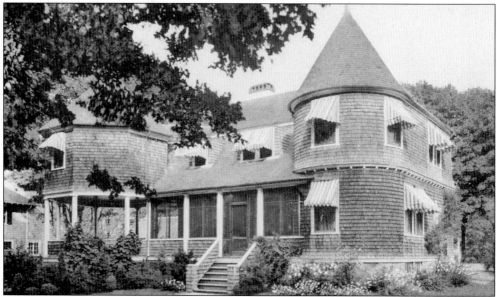

METATOXET COTTAGE. John H. Caswell built this two-story, gambrel-roofed dwelling in 1886. It was located at 64 Caswell Street adjacent to the Metatoxet Hotel and was rented to summer guests who preferred the privacy of a cottage. It remains today, with little modification, as a private residence. [Pub. Green's Art Store, Boardwalk, Narragansett, Rhode Island.]

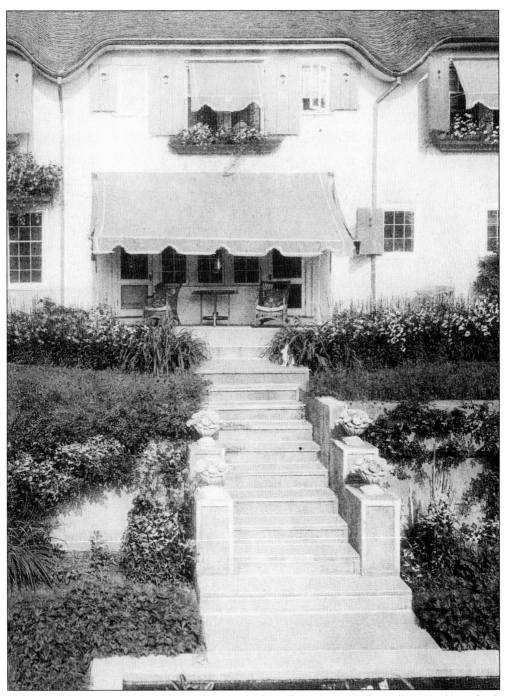

YELLOW PATCH, C. 1920S. Named for its colorful yellow stucco walls, Yellow Patch was built in 1916 for Kate Lane Richardson. It was designed by George F. Hall to resemble an English rural cottage with a thatched roof. Inside the large, front entrance is a grand staircase that divides to balconies serving second-floor rooms. The house, which is located at 115 Central Street, is maintained as a private residence. [Pub. Green's Art Store, Narragansett, Rhode Island.]

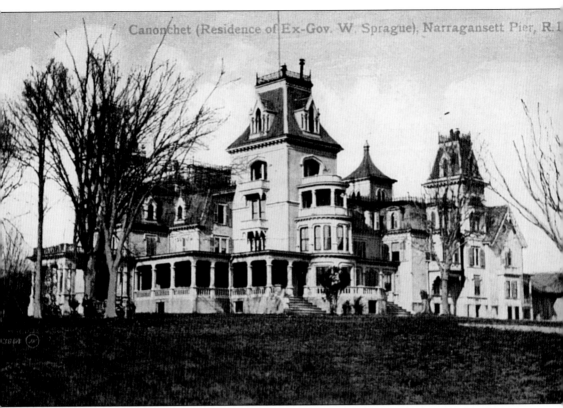

CANONCHET, C. 1908. In 1866, former governor William Sprague and his wife, Kate Chase Sprague, began construction of one of the largest, finest, and most unusual summer homes in Rhode Island. They employed the best architects, artisans, and craftsmen over a period of many years to achieve an ideal, which never seemed to be realized. Magnificent in proportion, peculiar in arrangement and decor, Canonchet stood in the center of a generous park-like area and commanded a panoramic view of Narragansett Bay. The main staircase ran to the top of the four-story mansion, which contained over 60 rooms. Construction costs were reported to be between $650,000 and $1 million. All of this grandeur was open to visitors two afternoons each week. In 1875, it became the permanent residence of the Spragues. In 1882, their marriage ended in scandal and divorce. In 1883, William married Inez Calvert, who left her own imprint on the design and furnishing of Canonchet. Sadly, this classic mansion was destroyed in a spectacular fire in 1909. All that remains today are the field stone walls of the carriage house, which is part of South County Museum grounds. [Pub. Valentine & Son's Co., New York.]

Seven

HIDDEN CORNERS
AND BYWAYS

COME FLY WITH ME, C. 1909. "Though the rest of the world swelters with heat, Narragansett remains cool and comfortably fanned by delicious ocean breezes. The air is seldom or never sultry, but full of ozone fresh and invigorating . . . Radiating from Narragansett are miles of splendid macadamized roads and shady country lanes which are features of continual interest and admiration to the automobilist, rider and driver" (Narragansett Chamber of Commerce, 1909). [Pub. J.A. Hollingsworth, Narragansett Pier, Rhode Island.]

SILVER LAKE, *c.* **1930s.** This beautiful lake straddles the Narragansett–South Kingstown line. It was known in Colonial times as "Kit's Pond" for Christopher Robinson, son of William H. Robinson, one of the affluent Narragansett planters. Christopher inherited the land around Silver Lake known as "Shadow Farm." Today, two condominium developments have incorporated the 19th-century farmhouse and Colonial Revival manor house. [Pub. Rhode Island News Co., Providence, Rhode Island.]

BONNET POINT, NARRAGANSETT, R.I. 21K.

BONNET POINT, *c.* **1930.** The Bonnet, as the area has been known for more than two centuries, remained undeveloped farmland until 1928, when an effort was made to transform the area into a major resort. The showcase for the resort was the Bonnet Shores Beach Club. Despite the loss of beach structures by hurricanes, Bonnet Shores has continued to develop, not as a resort, but as a lovely community with predominately permanent residences. The site of a Revolutionary War battery can still be seen atop the Bonnet cliffs. [Pub. Eastern Illustrating Co., Belfast, Maine.]

GOVERNOR SPRAGUE BRIDGE, C. 1930. The bridge was constructed by the State Board of Public Roads in 1921 to span the "Narrows." It replaced a 100-foot "covered bridge" built in 1868, which at the time was the longest in Rhode Island. By the late 1970s, the Sprague Bridge, then listed in the National Register of Historic Places, was considered unsound, and was replaced by the present structure. The north abutment of the old Sprague Bridge has been left standing as a tribute to its engineering and aesthetic significance. [Pub. Narragansett Gift Centre, Narragansett, Rhode Island.]

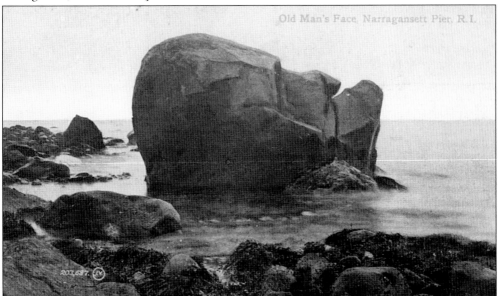

Old Man's Face, Narragansett Pier, R. I.

THE OLD MAN'S FACE, C. 1910. "Taking a stroll on the shore amongst the rocks, and remains of numerous wrecks, which are frequent here (Point Judith having long been a mariner's dread), all at once we notice before us the rock known as The Old Man's Face" (*Souvenir Book*, Narragansett Pier, RI: Hotel Men's Association, 1891) Perhaps the most photographed rock formation along the Narragansett shoreline, the Old Man's Face is no longer recognizable. The irresistible force of ocean waves has left only a jumble of rock. [Pub. Valentine & Son's Publishing Co., Ltd., New York.]

THE WORLD WAR II MEMORIAL, C. 1950S. The Veteran's Memorial Park, between Mathewson Street and Ocean Road, was purchased by the Town in 1931 and was the location of the original Narragansett Casino. The World War II Memorial contains bronze plaques listing 232 local servicemen (17 of whom gave their lives). The central panel features a high relief sculpture of a soldier by Florence (Peggy) Brevoort Kane, an internationally acclaimed sculptress. The model for the soldier was D-Day veteran William McKay, caretaker for Miss Kane's estate, "Mon Rêve," at 41 Gibson Avenue. [Pub. The Photo Shop, Wakefield, Rhode Island.]

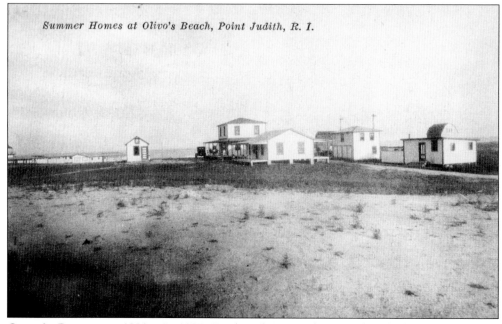

Summer Homes at Olivo's Beach, Point Judith, R. I.

OLIVO'S BEACH, C. 1930S. In 1927, Frank and Anna Olivo purchased what was known as Knowles Beach and developed a small but viable summer beach concession. Although the cottages did not survive the 1938 hurricane, Olivo's Beach did until 1979, when the state leased the 9-acre site, then purchased it, and incorporated it into Scarborough South Beach. [Pub. Frank Olivo, Point Judith, Rhode Island.]

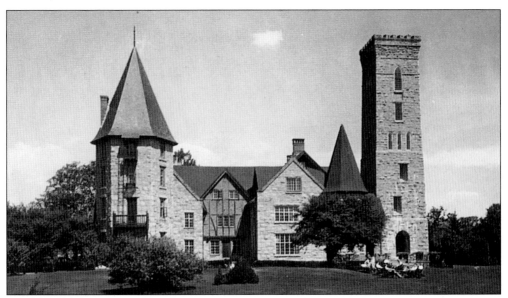

HAZARD'S CASTLE, C. 1920. The beautiful stone structure, built by Joseph Peace Hazard over many years (1846–1884), was modeled after an English abbey. The large rambling dwelling was the main house at Hazard's Seaside Farm and became a favorite attraction for summer visitors to Narragansett. Hazard's estate stretched from Narragansett Bay to Point Judith Road. [Pub. Frank Desmarais, Pawtucket, Rhode Island.]

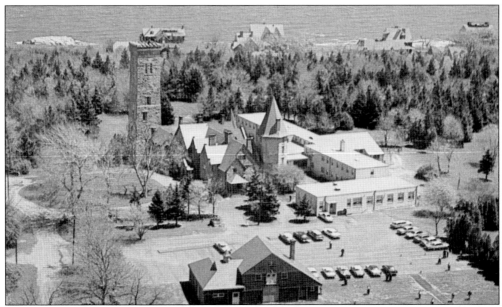

OUR LADY OF PEACE, C. 1960S. The Roman Catholic Diocese of Providence acquired the Hazard estate and, in 1952, established a men's retreat house. This aerial view looking east shows modifications including a large, flat-roofed wing added to the south and west sides. It has broaden its ministry over the years to welcome all who seek renewal of life through deepening their experience of God. In 1979, it became the "Spiritual Life Center" with programs that integrate scripture, theology, psychology, and spirituality. [Pub. Dexter Press, West Nyack, New York.]

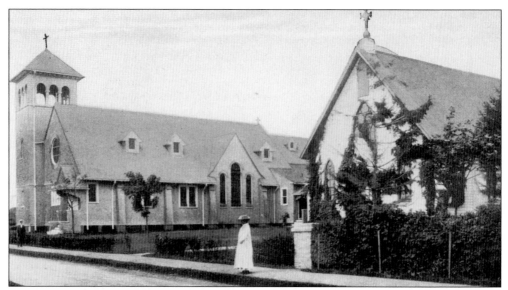

St. Philomena, c. 1920. The structure on the right was constructed as a summer church in 1883 for Catholic parishioners. It served as the primary place of worship until 1908, when the structure on the left was completed. The early building was then converted to other church use and then taken down in 1977. The church was rededicated to Saint Thomas More in 1961. [Pub. A.C. Bosselman & Co., New York.]

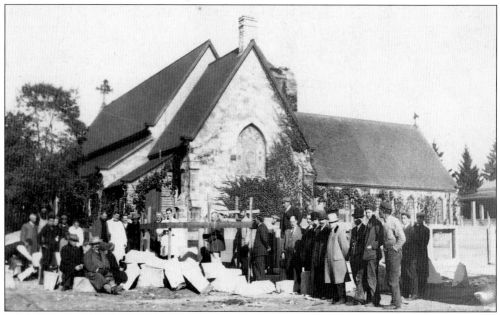

Saint Peter's-By-The-Sea, c. 1910. This beautiful stone structure has often been photographed from the front. This view is from the rear and shows the cornerstone ceremony for the new "Parish House" (a two-story, multi-purpose building used as a community center). The church itself was built in 1870–74 with later additions. It was modeled after English country churches and contains several remarkable Tiffany stained-glass windows and a bronze relief cast by Florence Kane. Located on Central Street, it remains a focus for the Episcopal faithful. [Pub. Anonymous.]

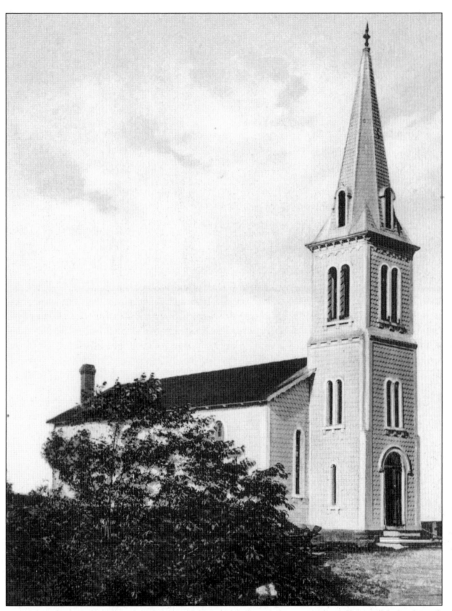

THE OLD SOUTH FERRY CHURCH, C. 1910. South Ferry was originally established in the late 17th century. John Franklin, brother to the more famous Benjamin, owned the ferry in the 18th century and is buried in the little cemetery across the road from the church. In the 19th century, a sizable settlement developed at South Ferry including shipbuilding, a cotton and woolen mill, stores, a school, a post office, tenement houses, and other support structures. In 1850 Baptists commissioned Thomas A. Tefft of Providence to design and build the one-story Victorian-style structure. The church is one of the finest early Victorian churches in Rhode Island. The economy and population of South Ferry significantly decreased after the Civil War, however; the church was continually used until 1908, when most of the members moved to a new chapel in Saunderstown. Concerned citizens funded restoration of the structure in 1946. Title passed to the University of Rhode Island in 1975 and the lovely structure is now used for special events such as weddings. [Pub. E.E. Briggs, Saunderstown, Rhode Island.]

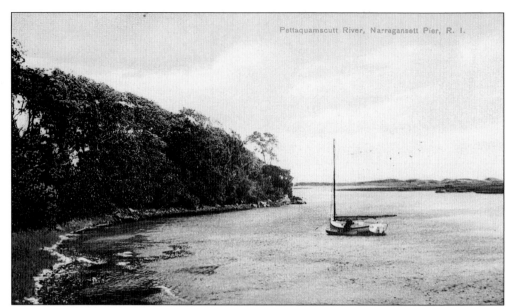

PETTAQUAMSCUTT RIVER, C. 1920s. Known also as "Narrow River," the Pettaquamscutt is actually a 5-mile long estuary forming much of Narragansett's western boundary. The southern part of the estuary, Pettaquamscutt Cove, is a large, shallow embayment bordered by salt marshes, which serve as important wildlife habitat. Joined to Narragansett Bay by a one-half-mile waterway, the Pettaquamscutt has been the setting for important commerce, such as boat building, as well as recreational fishing and boating. [Pub. Anonymous.]

SALT POND, C. 1920s. Officially known as Point Judith Pond, this 1,500-acre coastal pond is a shallow estuarine embayment with an average depth of about 6 feet. The pond supports a great variety of marine life including oysters, clams, blue crabs, scallops, bluefish, and flounder. Since Colonial times, it has supported vital fishing activities. Four-miles long and about a mile wide, the pond is separated from the ocean by a barrier beach. Since the early 20th century, a permanent man-made breachway at Galilee has fostered the growth of a large commercial and sport fishing industry. [Pub. Rhode Island News Co., Providence, Rhode Island.]

116

FISHING OFF THE ROCKS, C. 1950s. Sport fishing off the rugged shoreline at Narragansett was an attraction for many 19th-century visitors. At some locations, iron-fishing stands were bolted into the granite outcropping to provide safety and position. Sea Bass were highly prized with huge fish being routinely landed. Today, sport fishing from the shore is still popular but declining stocks provide only limited success. [Pub. Dexter Press Inc., West Nyack, New York.]

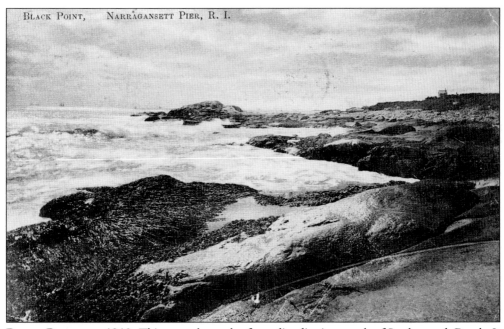

BLACK POINT, NARRAGANSETT PIER, R. I.

BLACK POINT, C. 1910. This rugged stretch of coastline lies just north of Scarborough Beach. It included a pathway used by Life Saving Service patrols as well as the public. In the 1980s, the 10-acre piece of property was primed for development when the State stepped in and acquired it. Today, this beautiful property is accessible to hikers and fishermen from Ocean Road. [Pub. Anonymous.]

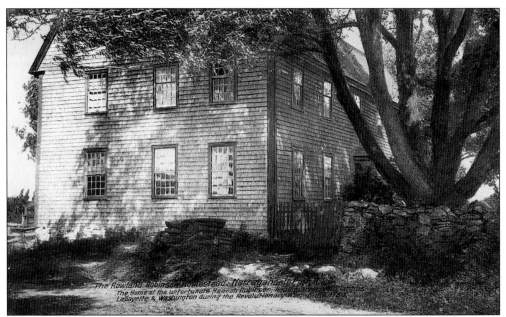

THE ROWLAND ROBINSON HOMESTEAD, C. 1910. Originally built in 1710, the house was extensively remodeled and enlarged in 1755. The Robinsons, who owned a large tract of land on Boston Neck, were among the most prominent of the Narragansett Planters. Hannah Robinson was born here and is the subject of a romantic tale that is one of South County's most colorful and popular legends. Architecturally, it is one of the finest houses of its period and is beautifully maintained as a private residence. [Pub. Printed in Great Britain.]

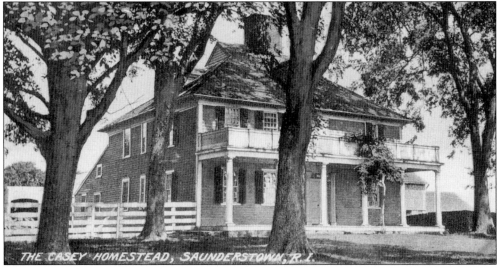

THE CASEY HOMESTEAD, C. 1910. The 300-acre working farm was a prosperous plantation in the mid-18th century. Five generations of the Casey family farmed the land with the aid of tenant farmers. The 1938 hurricane destroyed the front porch and large trees. In 1955, the New England Society for the Preservation of Antiquities purchased the historic farm to protect and preserve it for posterity. Today, resident farm managers operate a community-supported farm that is open to the public and raises organically grown vegetables, herbs, and flowers. [Pub. J.F. Sealey, Wickford, Rhode Island.]

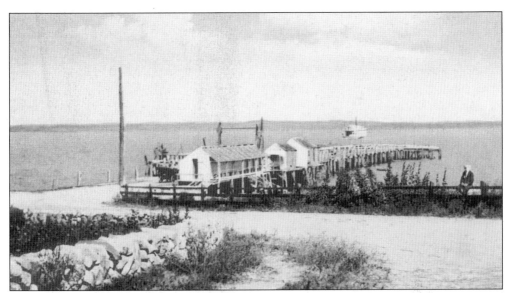

THE DOCK AT SAUNDERSTOWN, C. 1910. Saunderstown became a seaside village in 1855 when Captain John R. Saunders Jr., with his brothers and their families, purchased part of the old Willett farm. The shipbuilding family consolidated their operations on the waterfront and, in 1895, the Jamestown and Newport Ferry Co. began regular service to Saunders Wharf. A new hotel, store, and church became the center of a thriving community. However, the shore facilities were destroyed in the 1938 hurricane and Saunderstown settled back to a quiet residential community. [Pub. E.E. Briggs, Saunderstown, Rhode Island.]

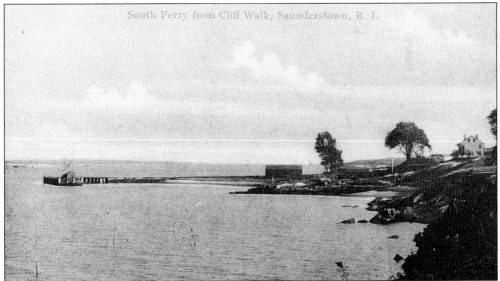

SOUTH FERRY, C. 1908. This rare postcard shows South Ferry from the north. The federal government acquired the site in 1901 and began constructing coastal artillery fortifications. A new wharf and storehouse can be clearly seen. The Colonial structure at the right edge of the picture was built by Captain Joseph Eaton in 1845 as an inn. When Fort Kearny was established, it served as NCO quarters. URI acquired the site after World War II and used the structure in its developing oceanography program. Unfortunately, it was destroyed by fire in 1959. [Pub. E.E. Briggs, Saunderstown, Rhode Island.]

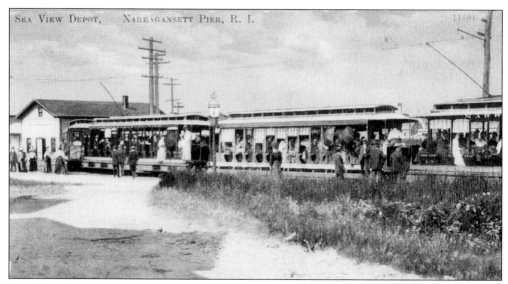

SEA VIEW DEPOT, NARRAGANSETT PIER, C. 1905. An electric trolley line called the Sea View was constructed from the Pier to Saunderstown in 1898. Designed to provide alternate passenger access to Narragansett, the line was extended to East Greenwich in 1900, where there was a connecting line to Providence. By 1902, the trolley interconnected with the Narragansett Pier Railroad lines to Peace Dale. There were 14 stations on the line between Wakefield and East Greenwich. The depot was later moved to 23 Brown Street and was converted into apartments. [Pub. Sam Podrat, Narragansett Pier, Rhode Island.]

SEA VIEW RAILROAD, C. 1905. This novelty postcard is a clever advertisement for the Sea View using window and wheel space for scenic images designed to entice ridership. The early years were the railroads best and most prosperous times. However, by 1920 the railroad had fallen on financial hard times and went quietly out of business. The old right-of-way, which generally parallels Boston Neck Road, is plainly visible in many locations. [Pub. Blanchard, Young & Co., Providence, Rhode Island.]

MIDDLE BRIDGE, C. 1938. This site across the Pettiquamscutt River was originally used by Colonials to travel from Tower Hill village to Boston Neck and Watson's Pier on Narragansett Bay. Since 1895, it has been a "famous fishing center." This view of the east side of Middle Bridge shows Louis Couchon's establishment, which included a boat livery service, bait shop, restaurant, and cabins. The restaurant, now known as Wiley's at Middle Bridge, is a favorite of locals. [Pub. Louis Couchon, Narragansett Pier, Rhode Island.]

KINNEY AVENUE, C. 1915. This wooded lane was built by Francis S. Kinney as a private way connecting his mansion on Ocean Road to the Anthony farm on Point Judith Road, which he purchased in 1897. Kinney, the founder of a successful New York tobacco firm, reportedly had a disagreement with the Point Judith County Club and built the "Bungalow" on the Anthony farm as a private clubhouse. Following Kinney's death, the road became town property. It remains a mile-long country lane to this day. [Pub. Anonymous.]

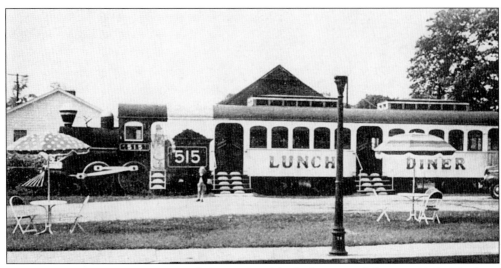

THE 515 DINER, C. 1940. Roy Bell designed and built this unusual diner in 1929. The basic structure was wood framed and sheathed with plywood. The unique design, once featured in *Popular Mechanics* magazine, had the kitchen configured in the "engine." It was located on Narragansett Avenue between Caswell and Beach Streets and was sturdy enough to survive the 1938 and 1954 hurricanes. However, it was not able to survive the changing economic conditions after World War II; it was razed in the mid-1950s and replaced with a gas station. [Pub. Leroy V. Bell, Wakefield, Rhode Island.]

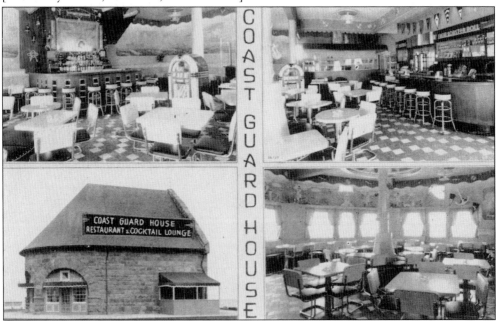

THE COAST GUARD HOUSE, C. 1950s. McKim, Mead, and White designed this unique stone structure in 1888 as a U.S. Life Saving Station for the Pier. Its form and materials harmonize with the nearby Towers. In 1938, the Coast Guard vacated the structure; it remained unused until 1946, when it was purchased by Dr. John A. Bolster, who created the Coast Guard House Restaurant and Cocktail Lounge. New owners have enlarged the restaurant, which has become one of the most popular in South County. [Pub. Vincent Payne, Providence, Rhode Island.]

AUNT CARRIE'S, C. 1930. In 1920, Carrie and Ulysses Cooper, shown here, bought property and opened a restaurant and tourist camp. The present counter area and front dining room is part of the original building, which has been expanded over the years. "Aunt Carrie" died in 1964, but her children and grandchildren have carried on the family tradition of fine seafood (especially their clam cakes), homemade breads, and pies. [Pub. Dexter Press, Pearl River, New York.]

SWEET MEADOWS INN, C. 1965. This interior view of the main dining room and garden entrance is a glimpse of an elegant inn that began as a Hazard family farmstead on Point Judith Road. Sarah Rodman Baldwin purchased the property in 1912. Baldwin constructed a beautiful Greek Revival home and commissioned Frederick Law Olmstead (the designer of Central Park) to create a formal English-style garden. In 1954, the estate was sold and converted into an inn with added motel units. The Washington Trust Co. purchased the inn in 1988; it now serves the community as a bank. [Pub. © L.K. Color Productions, Providence, Rhode Island.]

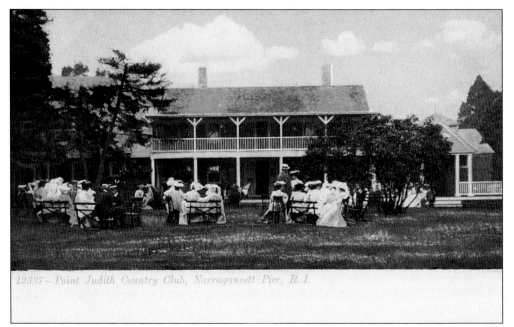

12337—Point Judith Country Club, Narragansett Pier, R. I.

THE POINT JUDITH COUNTRY CLUB, C. 1900. Philip S.P. Randolph and about 25 summer residents established the club on an extensive tract of land between Ocean Road and Point Judith Road in 1894. It was developed into a 180-acre golf course, polo fields, and tennis courts. In 1927, a lovely ballroom was added to the clubhouse. Today, the club remains a well-known, prestigious organization with 16 fine, grass tennis courts and a championship golf course. [Pub. Souvenir Postcard Co., New York.]

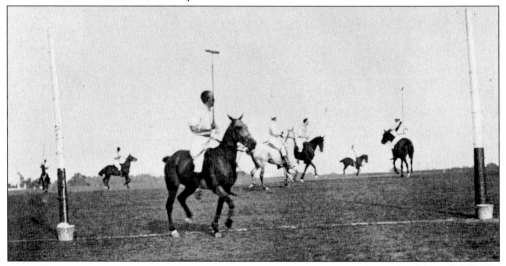

THE POINT JUDITH POLO CLUB, C. 1920s. The Point Judith Club joined the U.S. Polo Association in 1895 and attracted many well-known teams from Great British, India, and the U.S. Cavalry. Three polo fields, a practice field, and several barns were maintained at the Point Judith Country Club, where national and international tournaments were played in August. Polo declined in the 1930s, one of the last symbols of the old social elite. The old polo fields have found new life in a condominium development. [Pub. Rhode Island News Co., Providence, Rhode Island.]

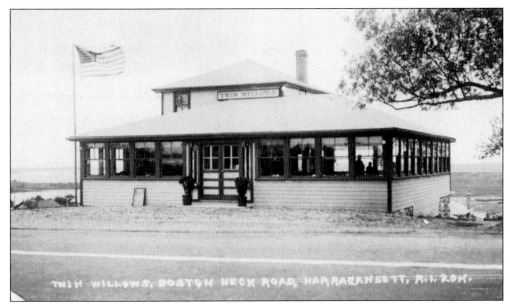

TWIN WILLOWS, C. 1930s. Twin Willows has long been one of South County's best-known "watering holes." In 1920, Charles and Mabel Bennett erected a small structure between two large willow trees on Boston Neck Road. Enlarged in the 1930s, it established a reputation of fine food and drink. A disastrous fire in 1979 totally destroyed the old structure, but a new building was quickly erected and old traditions were re-established. [Pub. Anonymous.]

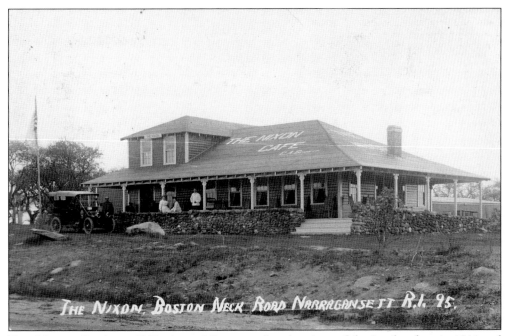

THE NIXON CAFÉ, C. 1920. Amey Nixon purchased a piece of the Jenckes farm in 1911 and built this handsome rustic structure. When Mrs. Nixon died, the family maintained the property until 1927. It was located on the northwest corner of what is now Mettatuxet and Boston Neck Roads. The property is now occupied by a group of six small rental cabins. [Pub. Anonymous.]

Ondawa (or Gin) Spring,
Narragansett Pier, R.I.

ONDOWA SPRINGS, C. 1910. Also known as "Gin" spring, this source of pure drinking water was located on the east side of Tower Hill and supplied water to the Tower Hill Hotel and surrounding buildings. The Victorians placed great importance upon health and sanitation; the availability of pure spring water from Ondowa and the Gladstone Spring (on Boon Street) made development of a fashionable resort possible before the advent of municipal water supplies. [Pub. Valentine & Sons Publishing Co., Ltd., New York.]

BLUE LITE TOURISTS, C. 1950S. Following World War II, the automobile and a booming economy provided many Americans the opportunity to travel. Southern Rhode Island attracted a new breed of summer tourists. Leon Inman started the Blue Lite in 1948 on Rhode Island Avenue and Ocean Road. By 1969, over 20 units were available. Today, the Blue Lite is gone but many of the "cottages" remain. [Pub. National Press, Inc., North Chicago, Illinois.]

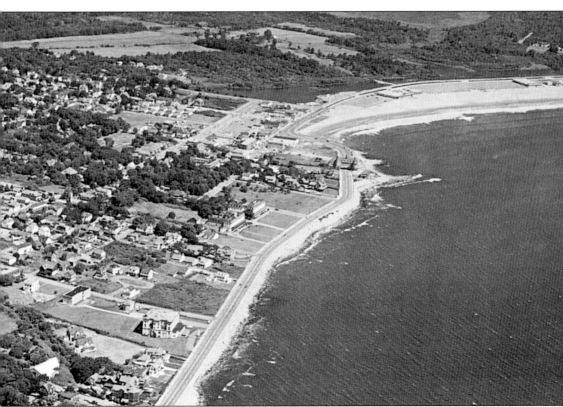

NARRAGANSETT PIER, C. 1960. This aerial view captures the Pier area near the beginning of its last transformation. Urban renewal would soon erase many of the remaining vestiges of a by-gone golden era. A careful examination of the photograph reveals the presence of the Green Inn and the Sea View, Carlton, Breakers, Ocean View, Surf, Massasoit, Bay View, and Atlantic Hotels. The large, white structure behind the post office is the Casino Theater. Even the Towers appear more majestic with its cupola intact. What is not evident is the decay and neglect of the buildings along Beach Street and Lower Kingstown Road. The beach, however, is lovely and inviting. The lure of the shore and salt water continues its appeal to visitors, but more dramatically, it has attracted permanent residences in large numbers. Today, Narragansett is one of the fastest growing towns in Rhode Island. Thankfully, it has retained its residential atmosphere and is known as a wonderful place to live with a fascinating history. [Pub © L.K. Color Productions, Providence, Rhode Island.]

ACKNOWLEDGMENTS

The colorful history of Narragansett can be well illustrated through hundreds of photographs. A much smaller number of vintage postcards have been preserved by individuals who have long taken a special interest in Narragansett's history. To these wonderful people, I am most indebted for the access and use of their postcard collections. Without their encouragement and support this book would not have been possible. Thank you Albert Brady, Priscilla Chappell, Jonathon A. "Coggie" Coggeshall, Sanford Neuschatz, Diane and Bob Smith, Donald and Shirley Southwick, Florence Sykes, and Charles "Ted" Wright.

The search for history is sometimes frustrating, but more often an adventure full of excitement, surprise, enlightenment, and a measure of fulfillment. These unselfish individuals have freely shared their knowledge and sense of historical adventure for which I am most grateful: Carolann Anderson, Cindy Belcourt, William F. Bolster Jr., Cindy Clancy, Peg Cocroft, Dorothy and John Cook, Dorothy Couchon, Barbara Culatta Ph.D., Earl Daniels, Dorothy Davis, Evangeline Doran Ph.D., Alan Easterbrook, Robert Eaton, Robert Eddy, Velma Flanagan, Marys (Hitchcock.) Hoagland, Rep. Leona A. and Milton Kelley, Richard Dana Latimer, Narragansett Town Manager Maurice Lootjens, Michael Maynard USCG, Susan Millard, John W. Miller, William and Elizabeth Northup, Director of South County Tourism Ann O'Neill, Robert F. Phelan Ph.D., Thomas Peirce, Lillian Potter, Philip S.P. Randolph III, Frank Robinson, Robert Sexton Ph.D., Susan Stone, Marise Whaley Sykes, Charisse Latimer Thompson, William Webster, Jack Westcott, and Barbara Wright.

A special thanks to these noted institutions and organizations: Book & Tackle, Watch Hill; Executive Realty; the Kingston Hill Store, Allison B. Goodsell; L.K. Colour Productions, Providence; the Narragansett Chamber of Commerce; the Narragansett Historical Society; Narragansett Town Hall Clerks; the Peace Dale Library Staff; the Pettaquamscutt Historical Society; the Rhode Island Historical Preservation Commission; the South County Museum; South County Tourism; the URI Graduate School of Oceanography; URI Library Special Collections; the Willett Free Library, Saunderstown; and Wilking Studio, Wakefield.

In memory of those who loved Narragansett's history and left their own legacy: James Doran, Winifred J. W. Kissouth, Florence Matson Sykes, Dr. Joseph Miller, Susan Northup Wilson, and Oliver Stedman.